東京

TOKYO GHOUL

TOKYO GHOUL
[ILLUSTRATIONS]
z a k k i

TOKYO GHOUL.

sui ishida

SUI ISHIDA

喰

種

Zakki

contents

The memorable first *Tokyo Ghoul* cover. Kaneki is holding Sen Takatsuki's *The Black Goat's Egg*.

I approached this with the vague feeling of wanting to make it have a bluish feel. I can tell I drew it tentatively.

I guess he's supposed to be wearing an Anteiku uniform.

This illustration was drawn using SAI.

III

2012 ● Volume 1 Cover

*All dates reflect year of release in Japan.

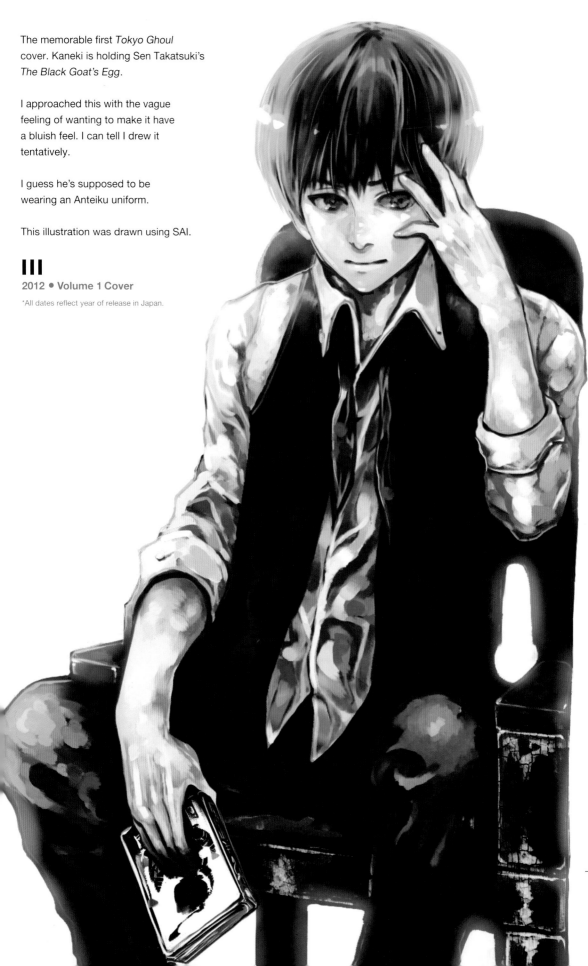

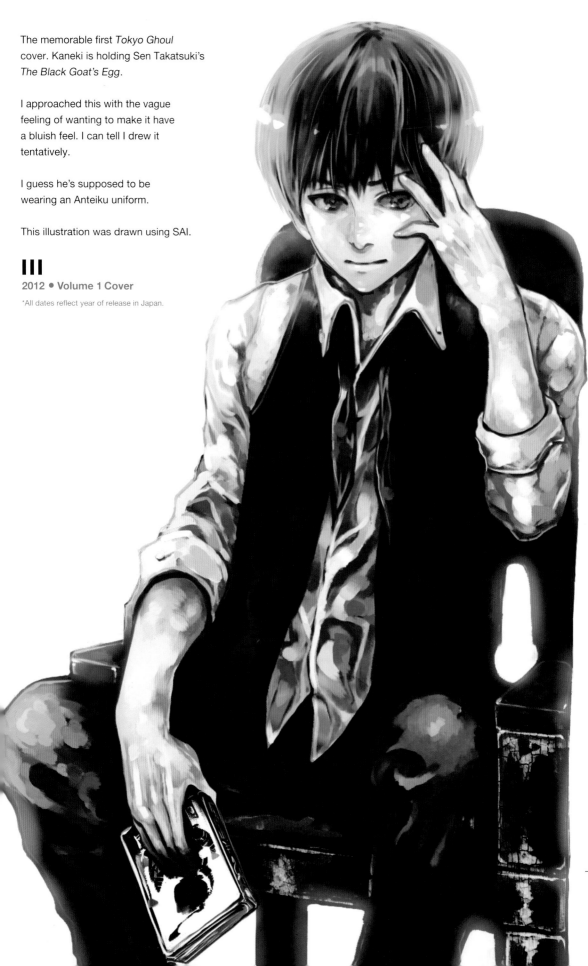

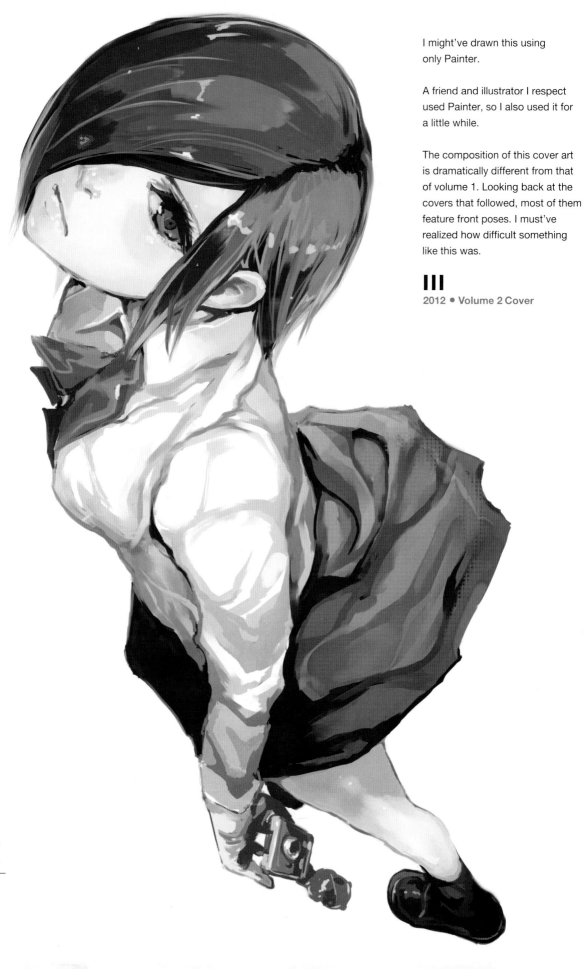

I might've drawn this using only Painter.

A friend and illustrator I respect used Painter, so I also used it for a little while.

The composition of this cover art is dramatically different from that of volume 1. Looking back at the covers that followed, most of them feature front poses. I must've realized how difficult something like this was.

III

2012 ● Volume 2 Cover

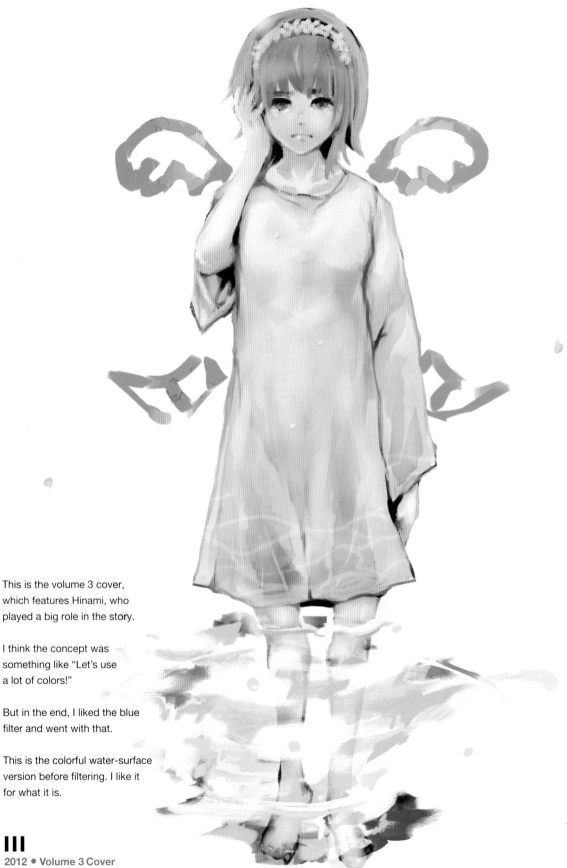

This is the volume 3 cover, which features Hinami, who played a big role in the story.

I think the concept was something like "Let's use a lot of colors!"

But in the end, I liked the blue filter and went with that.

This is the colorful water-surface version before filtering. I like it for what it is.

III
2012 • Volume 3 Cover

The theme is "sit him in a nice chair wearing strange clothes."

I remember my assistant at the time saying this character might become popular after his first appearance.

Shu Tsukiyama was originally the main character of a piece I submitted to a manga publisher that had nothing to do with the main story of *Tokyo Ghoul*.

He would step on poop or touch *konjaku* with Chiehori, the photographer girl, in the *Tokyo Ghoul* novel.

That will never see the light of day. I don't want it to either.

He's a character I've known longer than Kaneki.

III
2012 ●
Volume 4 Cover

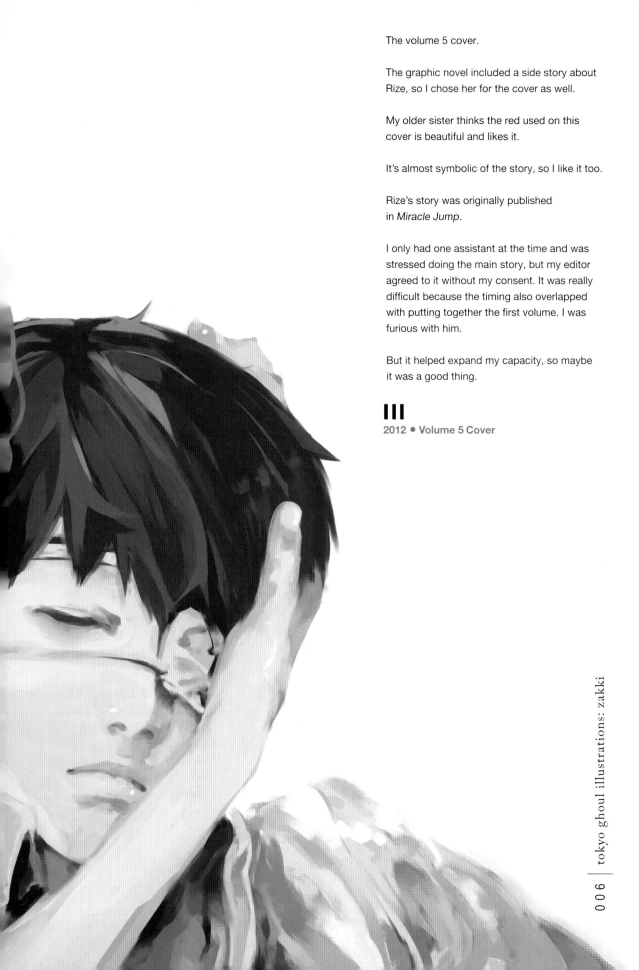

The volume 5 cover.

The graphic novel included a side story about Rize, so I chose her for the cover as well.

My older sister thinks the red used on this cover is beautiful and likes it.

It's almost symbolic of the story, so I like it too.

Rize's story was originally published in *Miracle Jump*.

I only had one assistant at the time and was stressed doing the main story, but my editor agreed to it without my consent. It was really difficult because the timing also overlapped with putting together the first volume. I was furious with him.

But it helped expand my capacity, so maybe it was a good thing.

III

2012 ● Volume 5 Cover

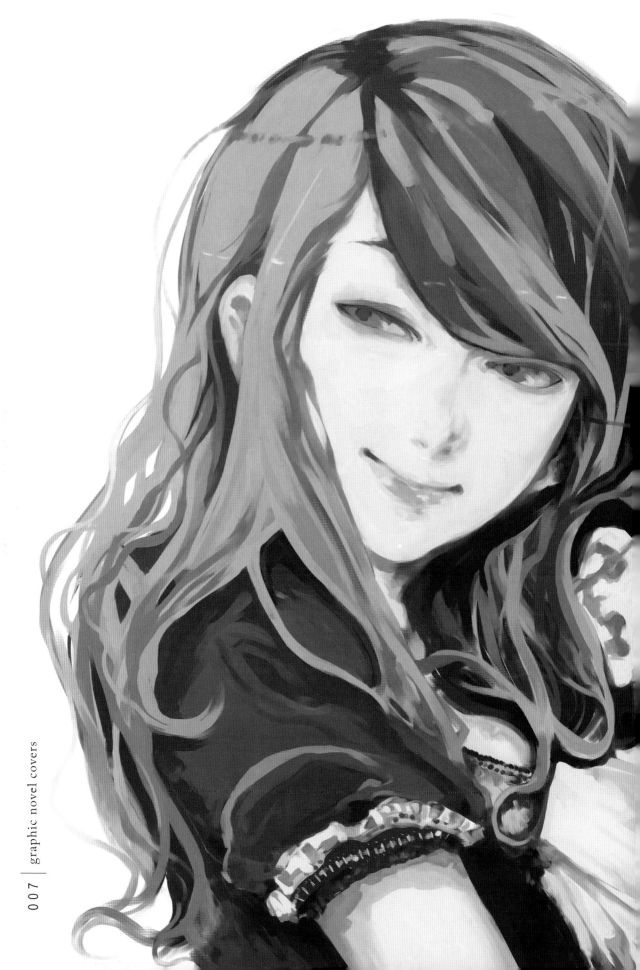

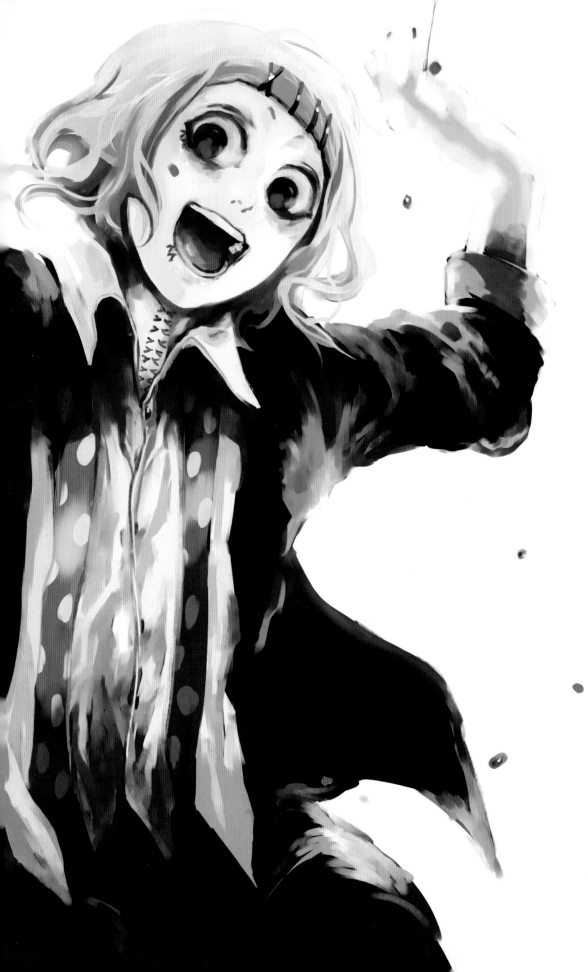

| tokyo ghoul illustrations: zakki

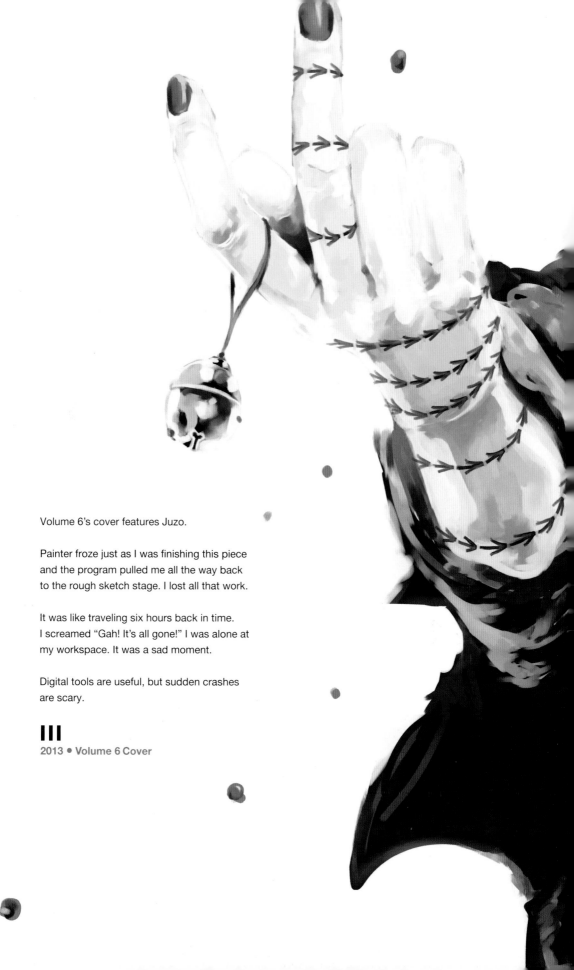

Volume 6's cover features Juzo.

Painter froze just as I was finishing this piece and the program pulled me all the way back to the rough sketch stage. I lost all that work.

It was like traveling six hours back in time. I screamed "Gah! It's all gone!" I was alone at my workspace. It was a sad moment.

Digital tools are useful, but sudden crashes are scary.

III
2013 ● Volume 6 Cover

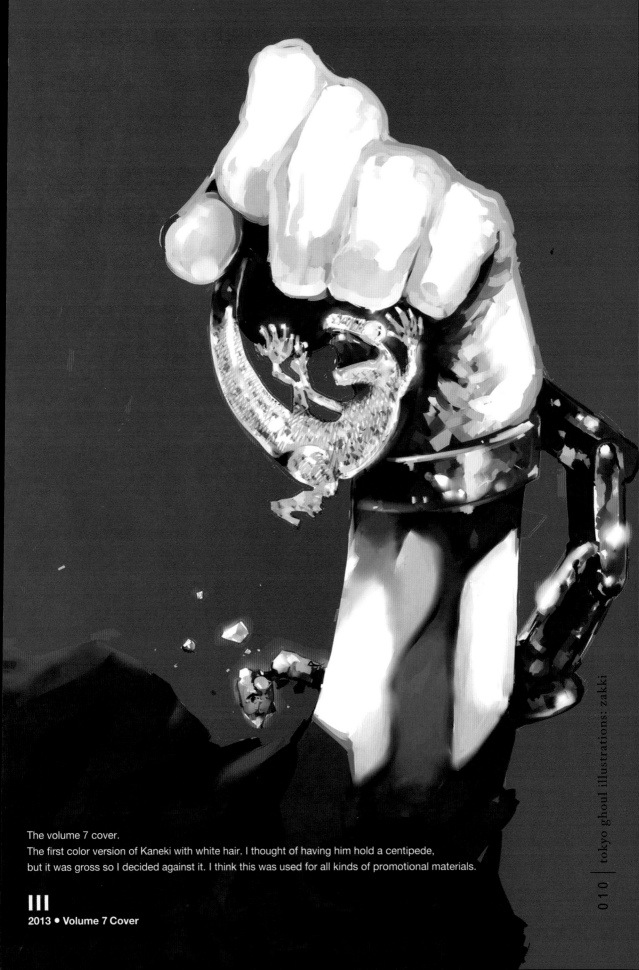

The volume 7 cover.
The first color version of Kaneki with white hair. I thought of having him hold a centipede,
but it was gross so I decided against it. I think this was used for all kinds of promotional materials.

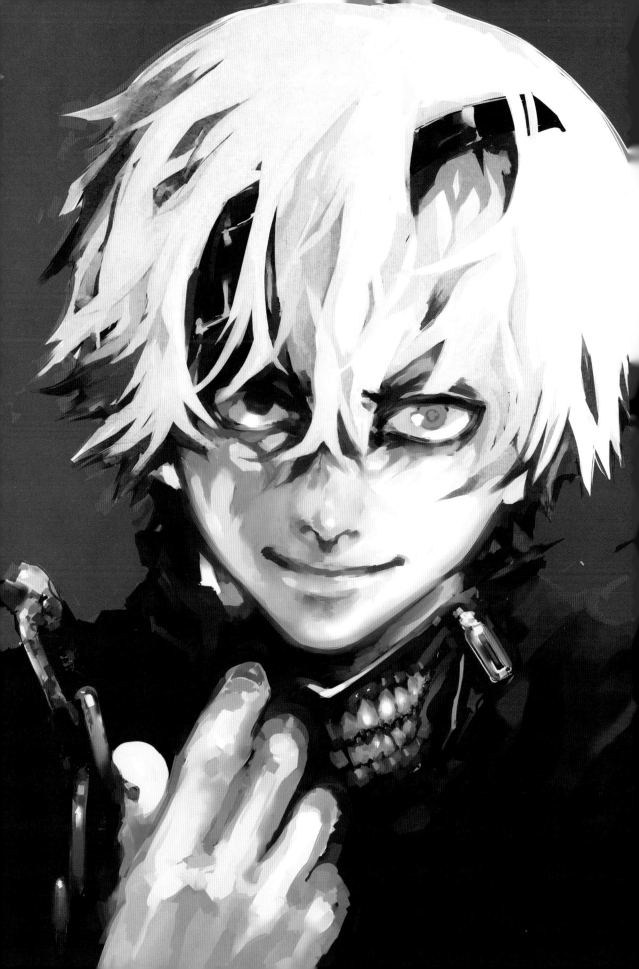

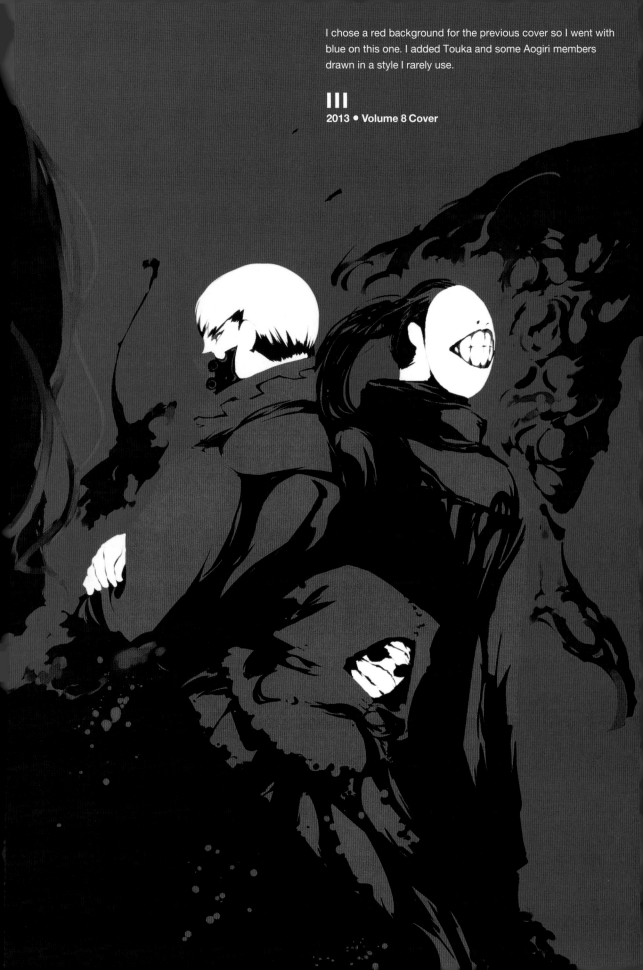

I chose a red background for the previous cover so I went with blue on this one. I added Touka and some Aogiri members drawn in a style I rarely use.

III
2013 • Volume 8 Cover

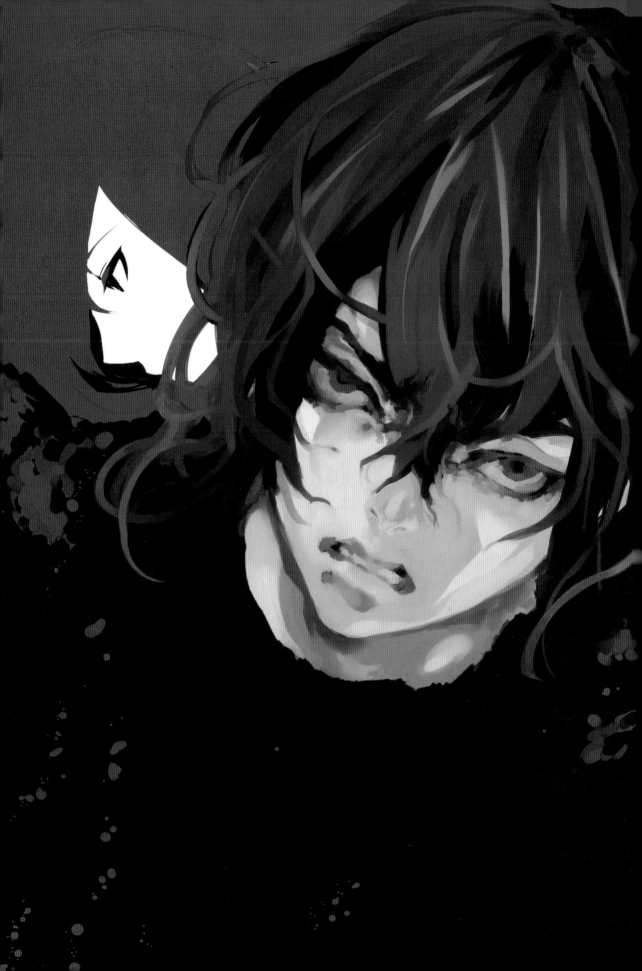

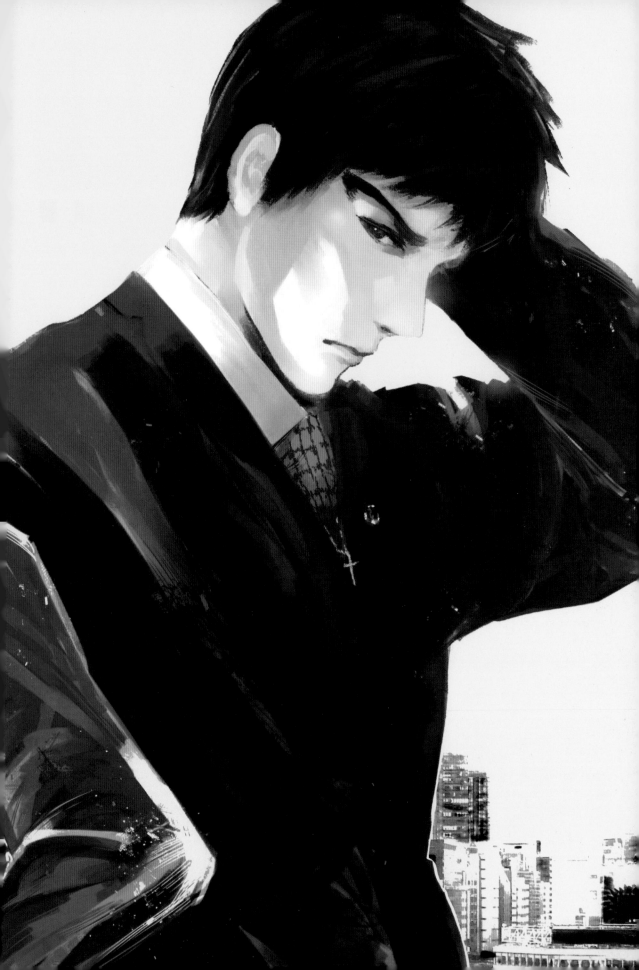

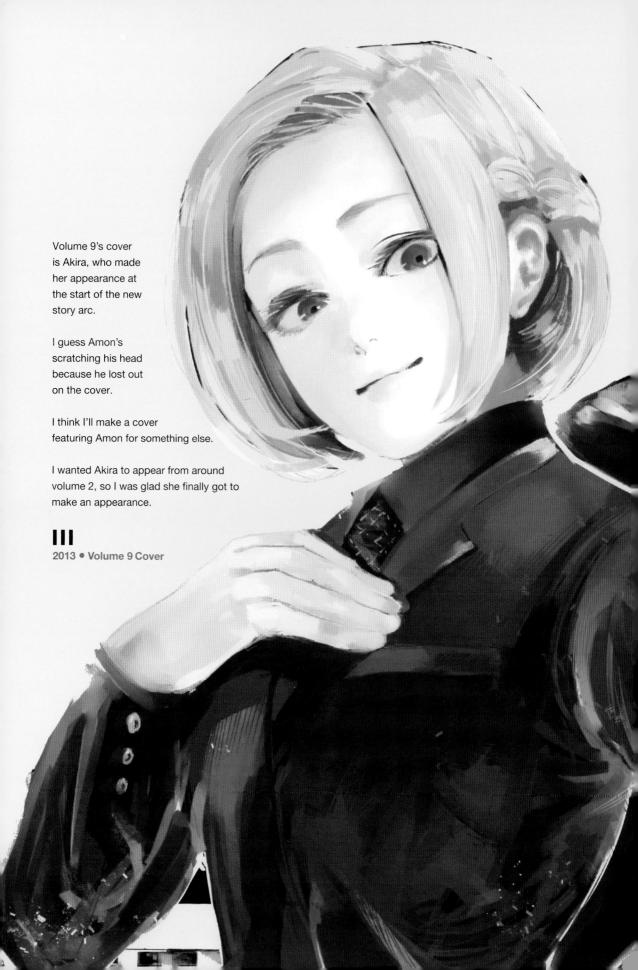

Volume 9's cover
is Akira, who made
her appearance at
the start of the new
story arc.

I guess Amon's
scratching his head
because he lost out
on the cover.

I think I'll make a cover
featuring Amon for something else.

I wanted Akira to appear from around
volume 2, so I was glad she finally got to
make an appearance.

III
2013 ● Volume 9 Cover

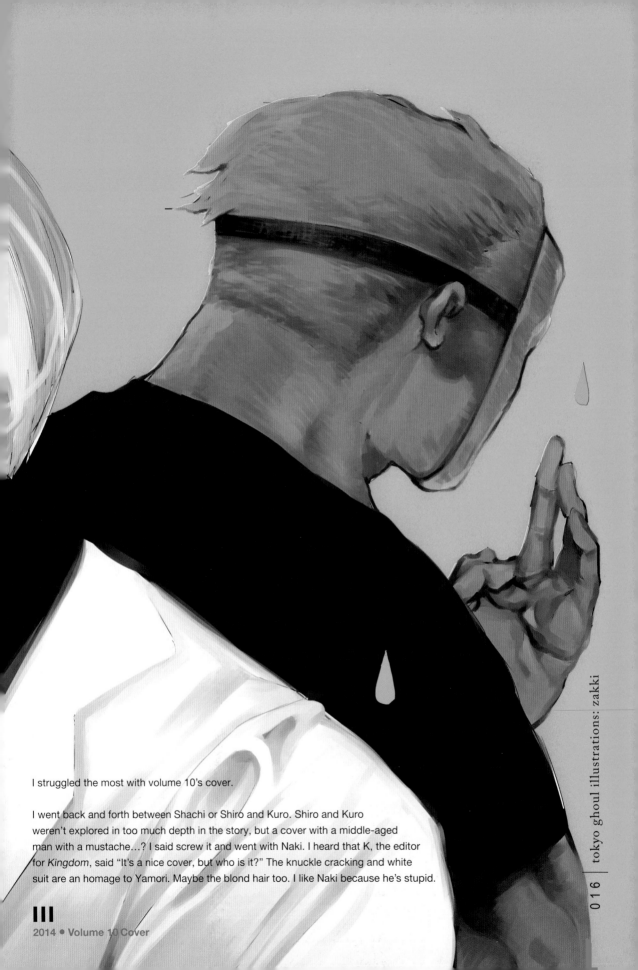

I struggled the most with volume 10's cover.

I went back and forth between Shachi or Shiro and Kuro. Shiro and Kuro weren't explored in too much depth in the story, but a cover with a middle-aged man with a mustache...? I said screw it and went with Naki. I heard that K, the editor for *Kingdom*, said "It's a nice cover, but who is it?" The knuckle cracking and white suit are an homage to Yamori. Maybe the blond hair too. I like Naki because he's stupid.

III

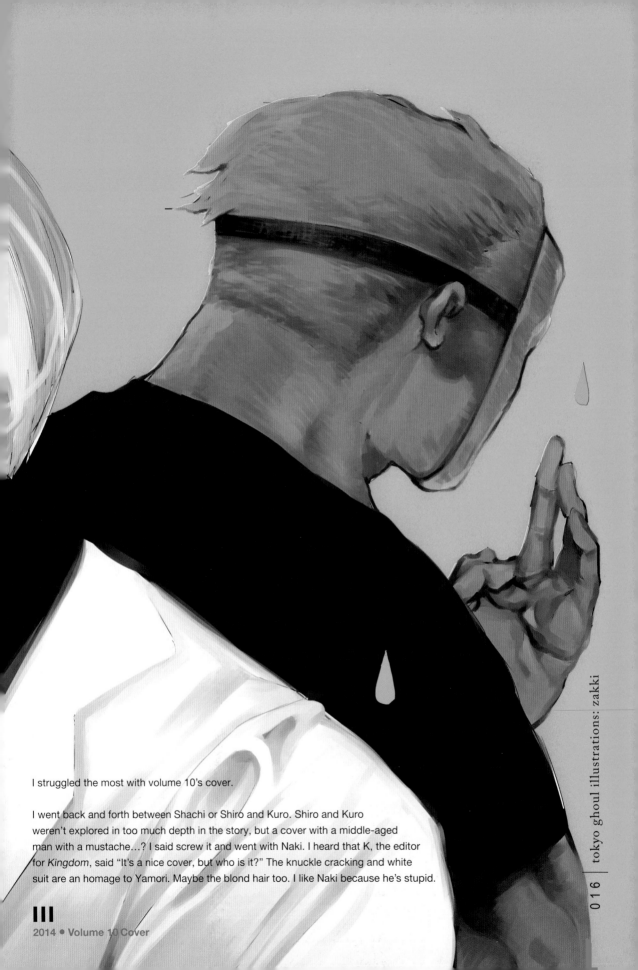

016 | tokyo ghoul illustrations: zakki

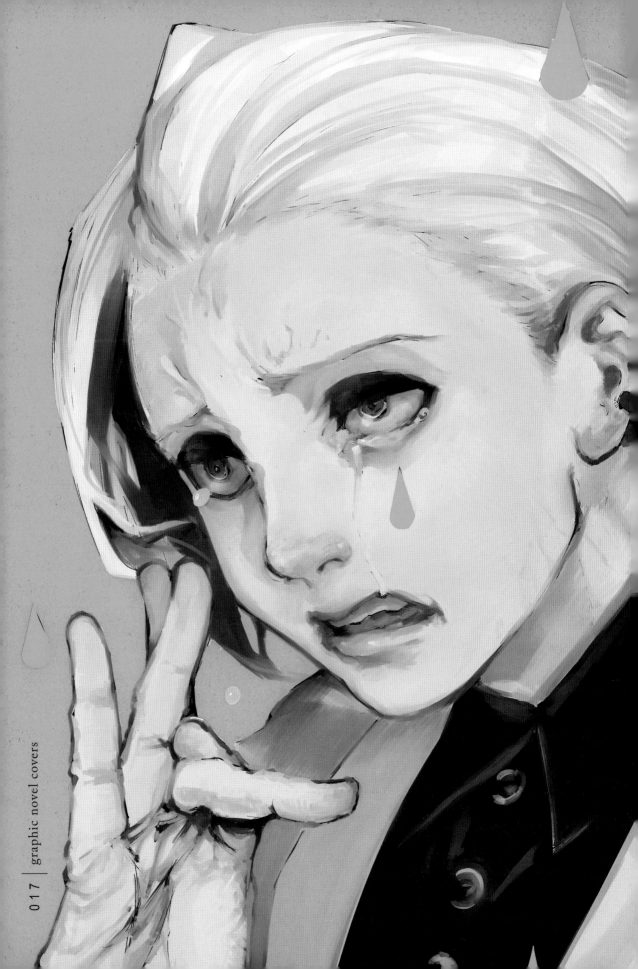

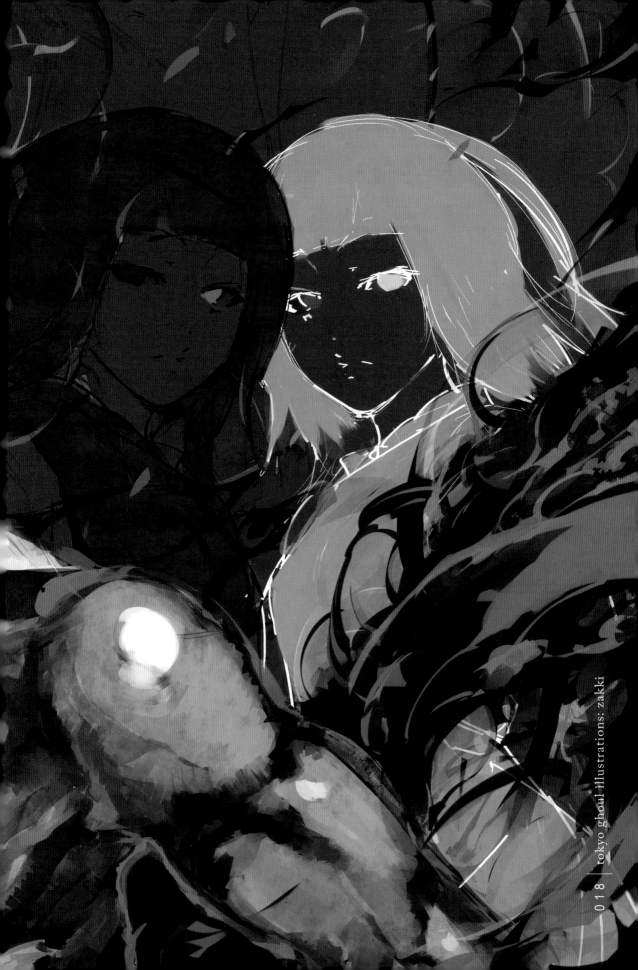

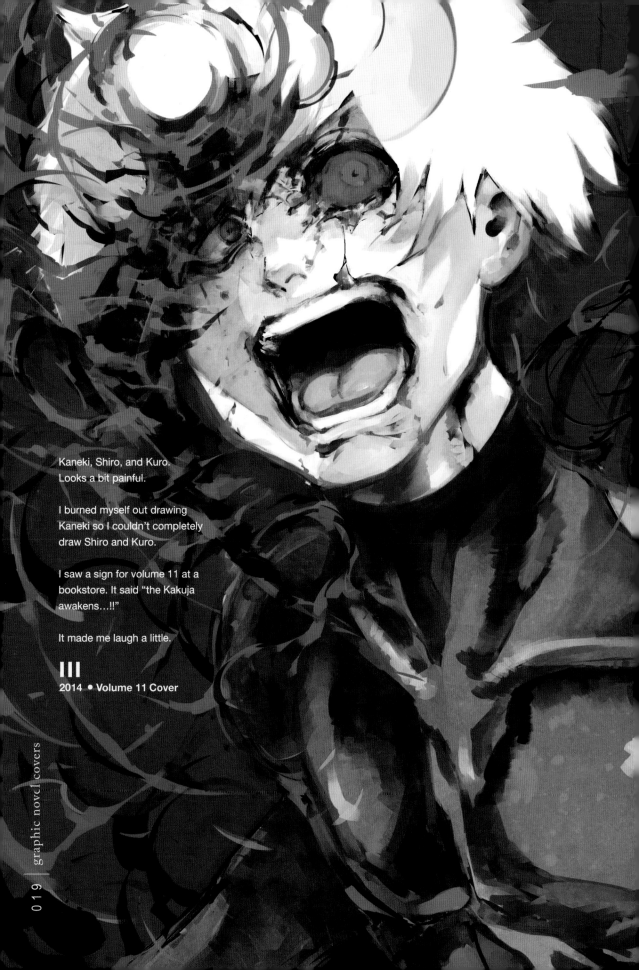

Kaneki, Shiro, and Kuro.
Looks a bit painful.

I burned myself out drawing
Kaneki so I couldn't completely
draw Shiro and Kuro.

I saw a sign for volume 11 at a
bookstore. It said "the Kakuja
awakens...!!"

It made me laugh a little.

2014 • Volume 11 Cover

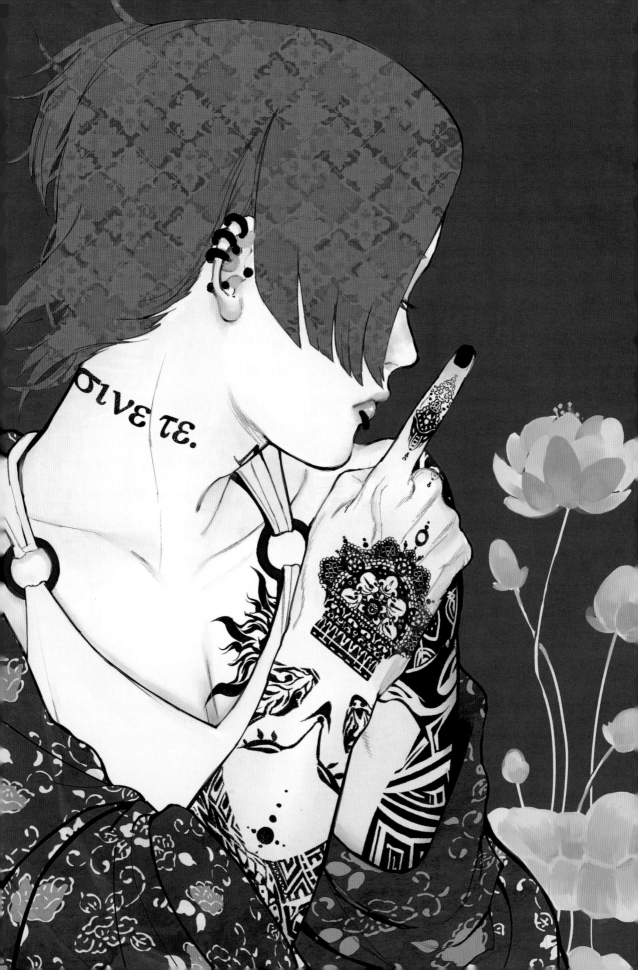

Volume 12 is Uta. I went with a profile pose, though I feel like that's a taboo for covers. Next to him are lotus flowers.

I wanted to try a different style, so I didn't fill the image in with too much color and left it relatively bare.

The back cover is Yomo.

I considered Yomo for the cover, but I wanted to give him the cover for a better volume, so I went with Uta.

He's got that sad, sulking look.

III
2014 ● Volume 12 Cover

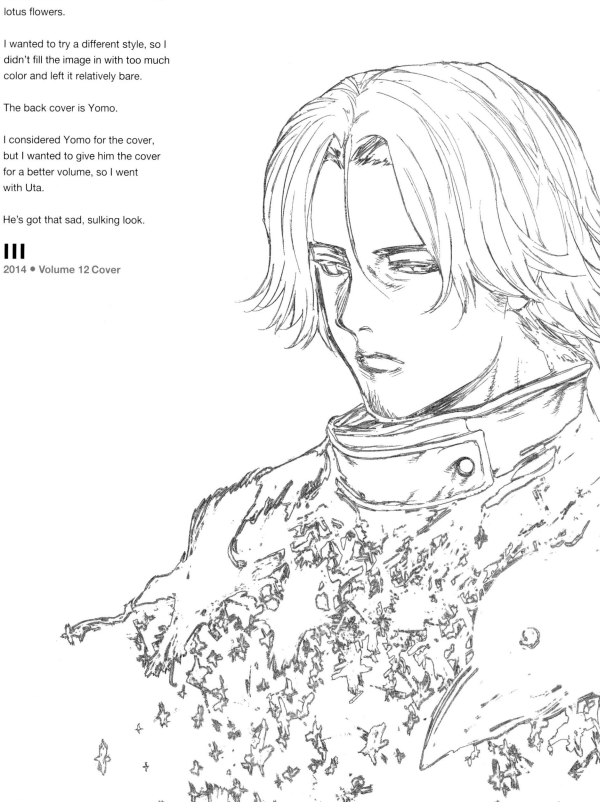

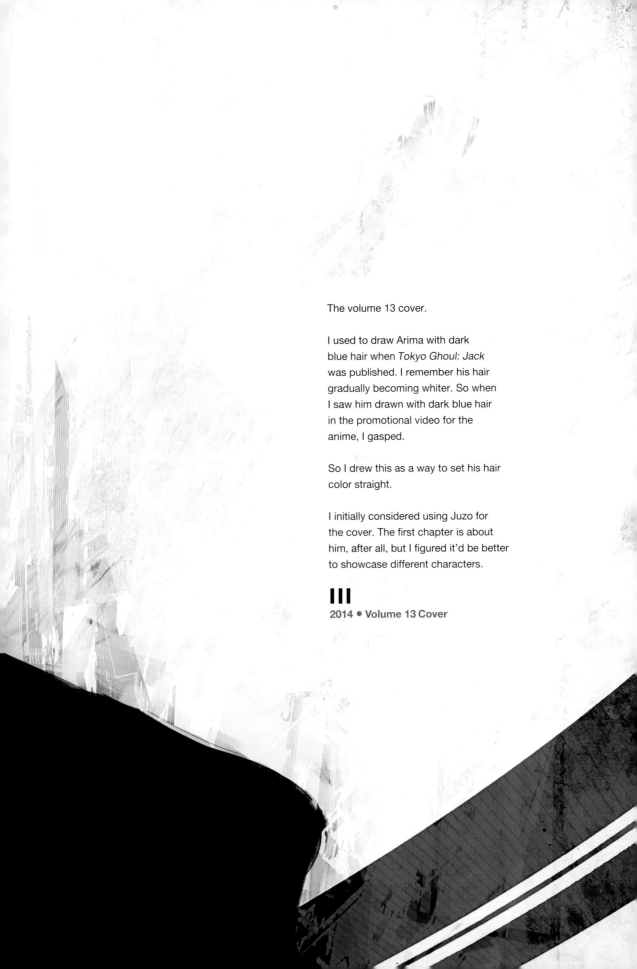

The volume 13 cover.

I used to draw Arima with dark
blue hair when *Tokyo Ghoul: Jack*
was published. I remember his hair
gradually becoming whiter. So when
I saw him drawn with dark blue hair
in the promotional video for the
anime, I gasped.

So I drew this as a way to set his hair
color straight.

I initially considered using Juzo for
the cover. The first chapter is about
him, after all, but I figured it'd be better
to showcase different characters.

III

2014 ● Volume 13 Cover

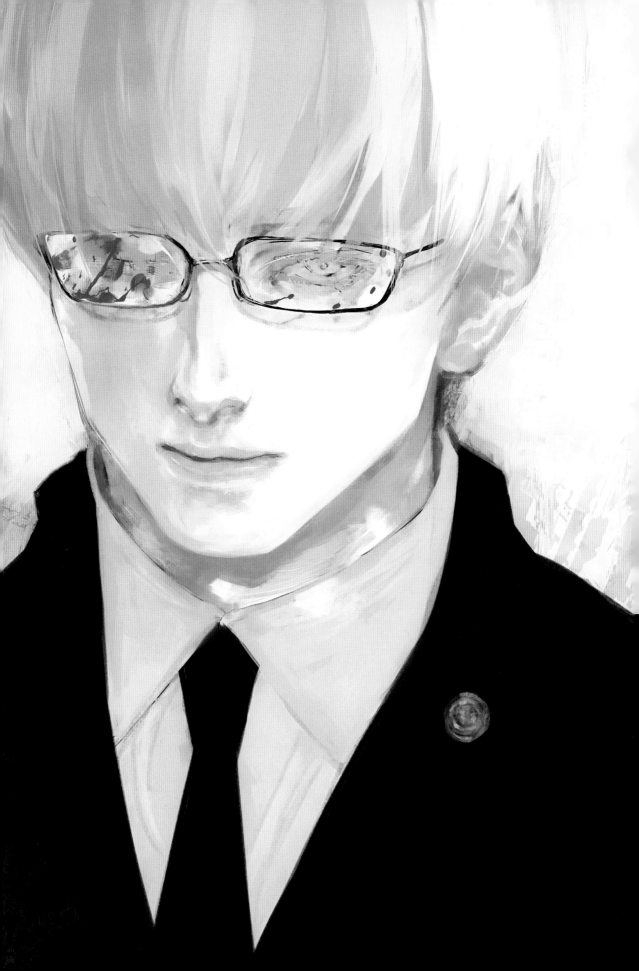

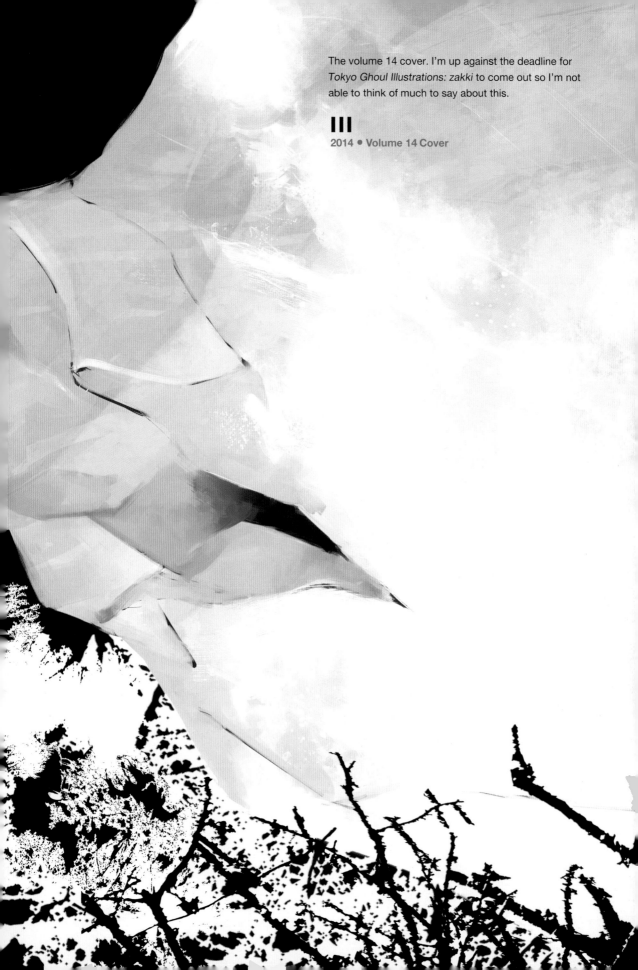

The volume 14 cover. I'm up against the deadline for
Tokyo Ghoul Illustrations: zakki to come out so I'm not
able to think of much to say about this.

III
2014 ● **Volume 14 Cover**

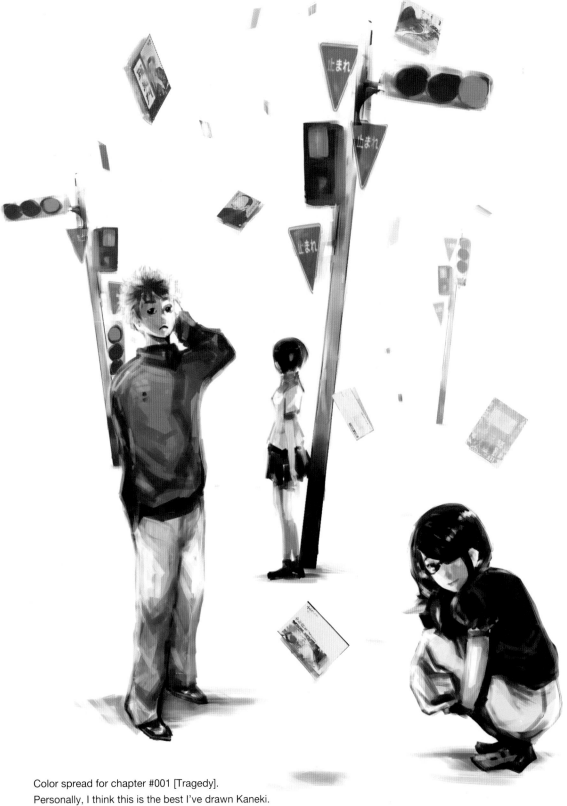

Color spread for chapter #001 [Tragedy].
Personally, I think this is the best I've drawn Kaneki.
Drawing him keeps getting harder and harder.

III

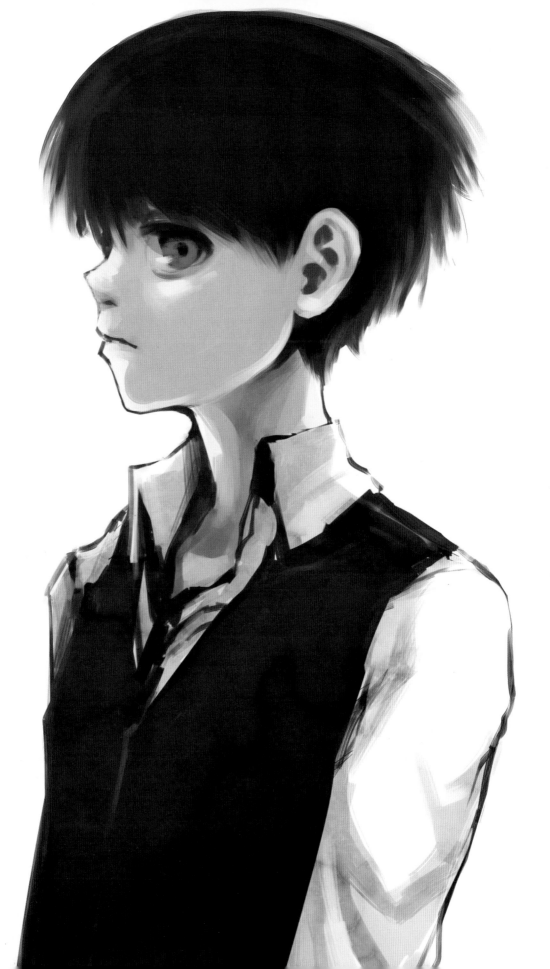

Chapter #004 [Coffee] illustration.

When the series first started, I was required to create multiple color illustrations. I wasn't used to it, so I was overwhelmed.

I kinda like the road signs and stuff in the background.

III
Young Jump 2011 • No. 44
Title Color Page Illustration

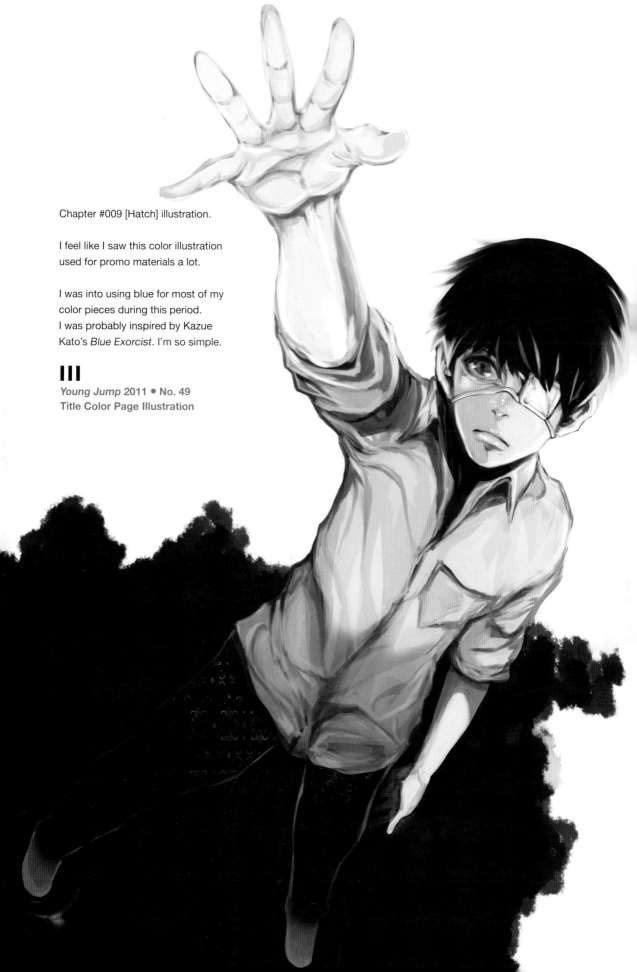

Chapter #009 [Hatch] illustration.

I feel like I saw this color illustration used for promo materials a lot.

I was into using blue for most of my color pieces during this period.
I was probably inspired by Kazue Kato's *Blue Exorcist*. I'm so simple.

III
Young Jump 2011 • No. 49
Title Color Page Illustration

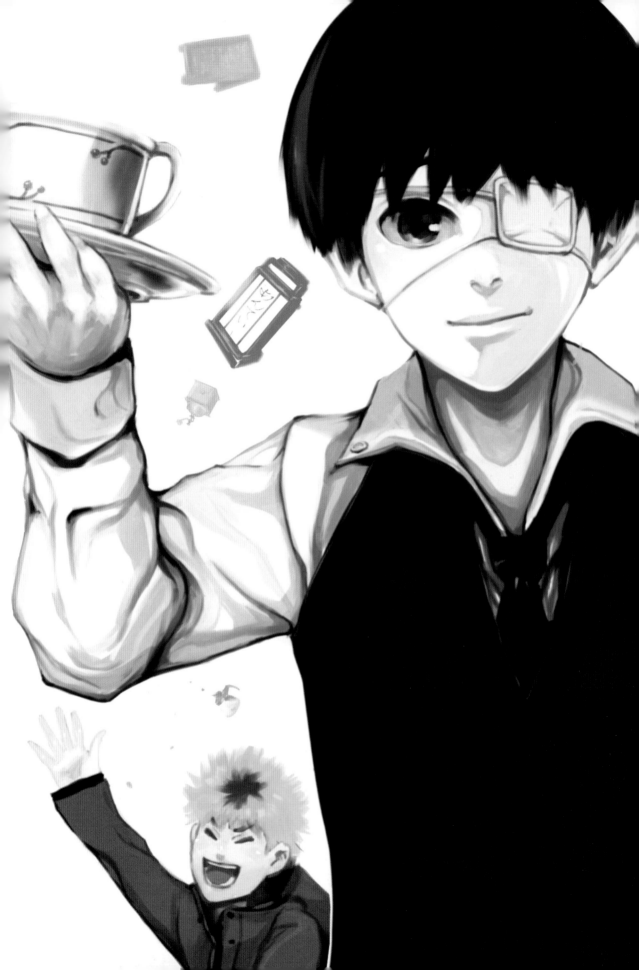

The color spread for the new story arc with extra pages that I drew after the grueling schedule required to finish volume 1 and Rize's side story.

I like the contrast between Kaneki's slight exuberance after joining Anteiku and the utterly not exuberant situation I was in at the time.

Yomo's shaggy hair is cute. I think I made all those things raining down to match chapter #001's color illustration.

At the time, I wasn't used to collaborating with an editor. I was wary of the whole process. After thinking it through, I nervously suggested creating the story more on my own. His response was "That's what I've been waiting to hear." My knees almost gave out. I wonder if he meant it…

We get along great, just so you know.

III

Young Jump 2012 ● No. 1 ● Title Page Color Illustration

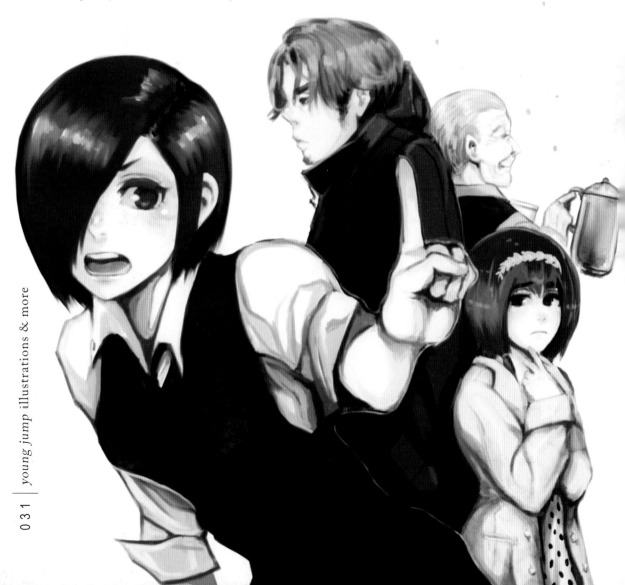

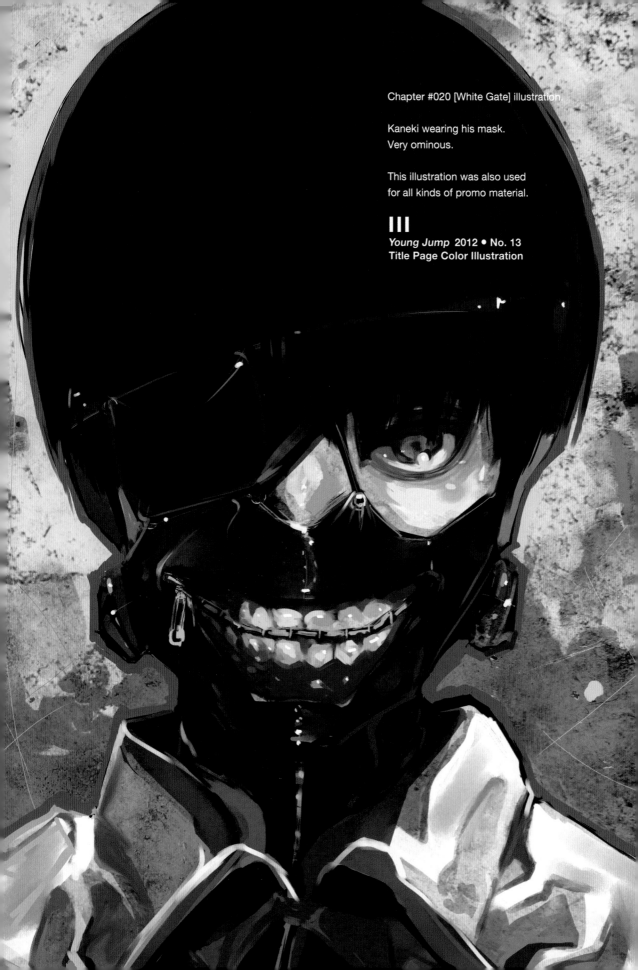

Chapter #020 [White Gate] illustration.

Kaneki wearing his mask.
Very ominous.

This illustration was also used
for all kinds of promo material.

III
Young Jump 2012 • No. 13
Title Page Color Illustration

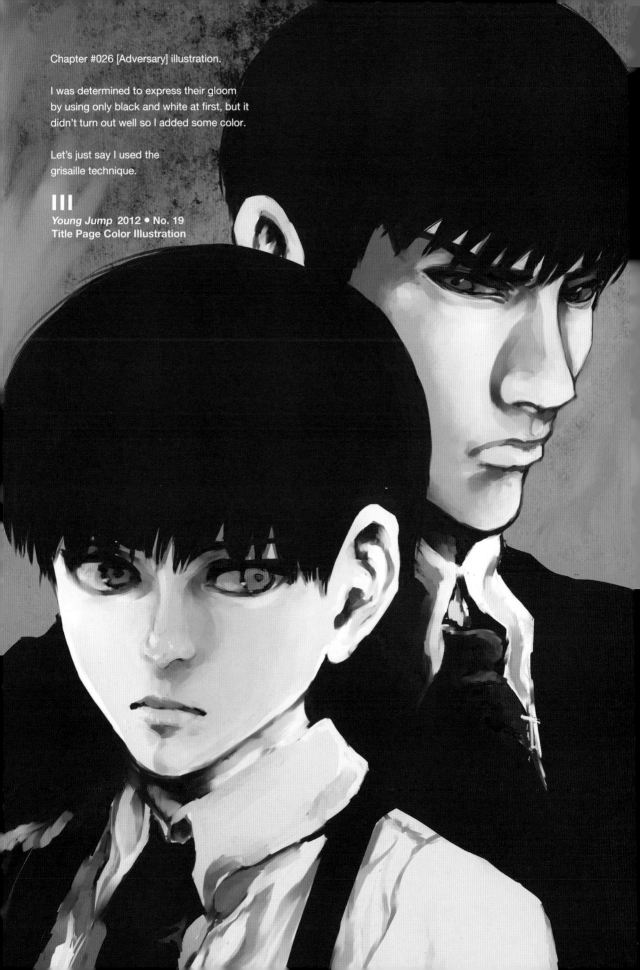

Chapter #026 [Adversary] illustration.

I was determined to express their gloom
by using only black and white at first, but it
didn't turn out well so I added some color.

Let's just say I used the
grisaille technique.

||||
Young Jump 2012 • No. 19
Title Page Color Illustration

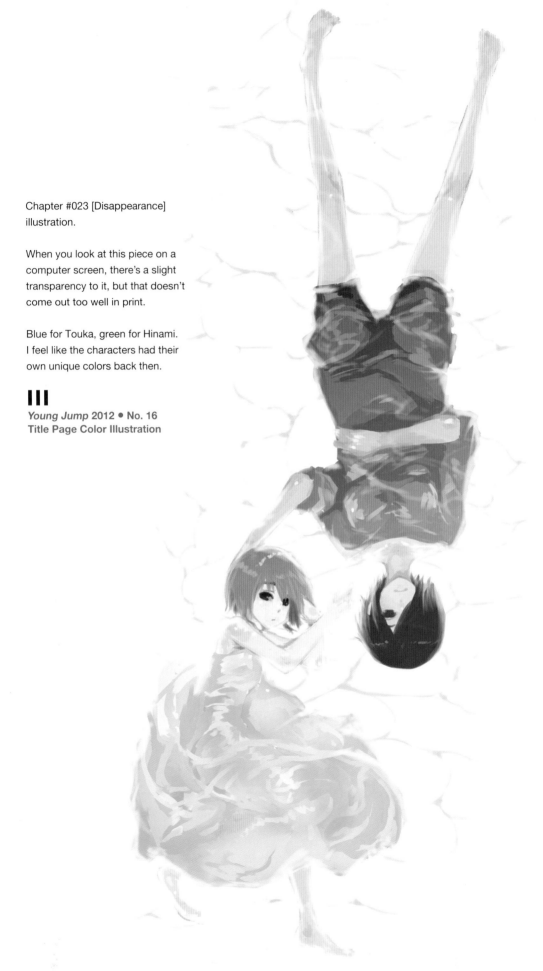

Chapter #023 [Disappearance]
illustration.

When you look at this piece on a
computer screen, there's a slight
transparency to it, but that doesn't
come out too well in print.

Blue for Touka, green for Hinami.
I feel like the characters had their
own unique colors back then.

III
Young Jump 2012 ● No. 16
Title Page Color Illustration

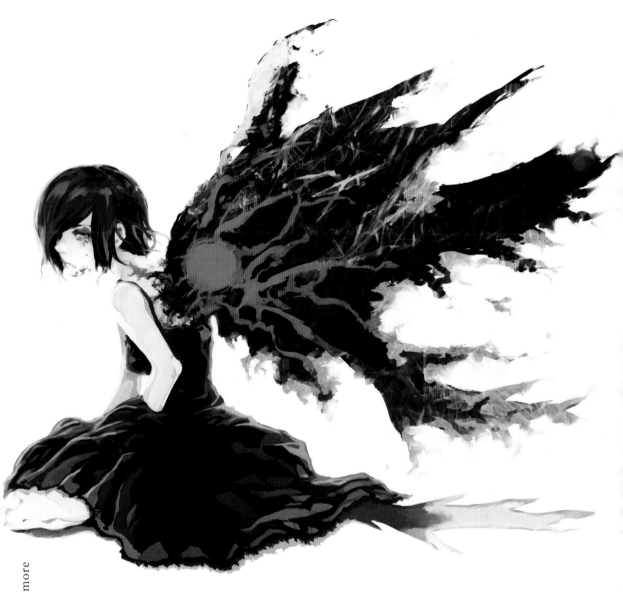

Chapter #045 [Black Wings] illustration.
Around the time of Tsukiyama's
church arc.

This was used for a bookstore gift
card, so that's how I see it.

III

Young Jump 2012 ● No. 41
Title Page Color Illustration

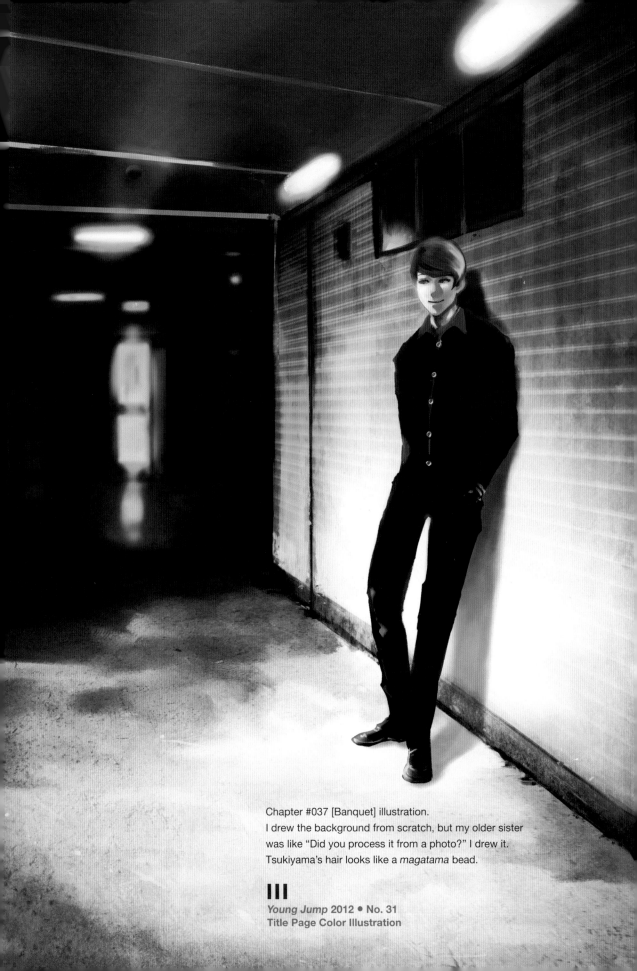

Chapter #037 [Banquet] illustration.
I drew the background from scratch, but my older sister
was like "Did you process it from a photo?" I drew it.
Tsukiyama's hair looks like a *magatama* bead.

▌▌▌
Young Jump 2012 • No. 31
Title Page Color Illustration

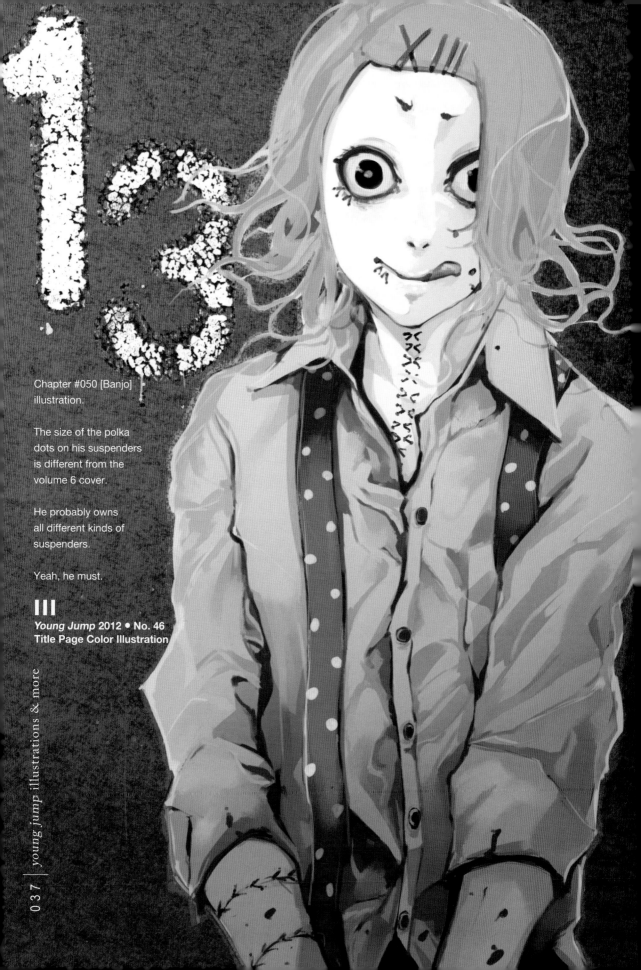

1₃

Chapter #050 [Banjo]
illustration.

The size of the polka
dots on his suspenders
is different from the
volume 6 cover.

He probably owns
all different kinds of
suspenders.

Yeah, he must.

Ⅲ
Young Jump 2012 • No. 46
Title Page Color Illustration

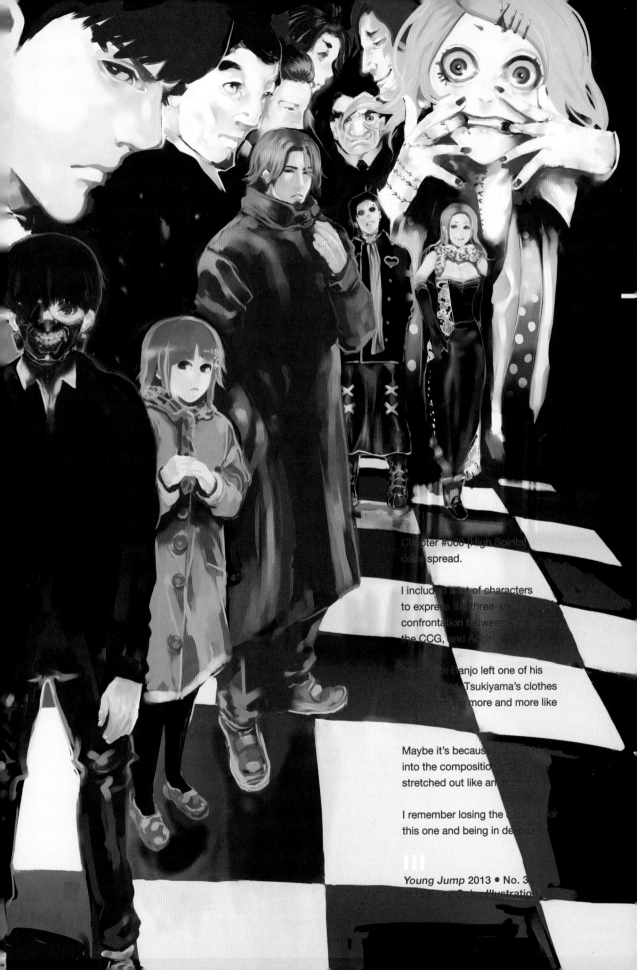

Chapter #066 [High Spirits]
color spread.

I included a lot of characters
to express the three-way
confrontation between Anteiku,
the CCG, and Aogiri.

I think the Banjo left one of his
shoes behind. Tsukiyama's clothes
are becoming more and more like
a swimming flag.

Maybe it's because I broke free
into the composition with legs
stretched out like an insect.

I remember losing the data file for
this one and being in despair.

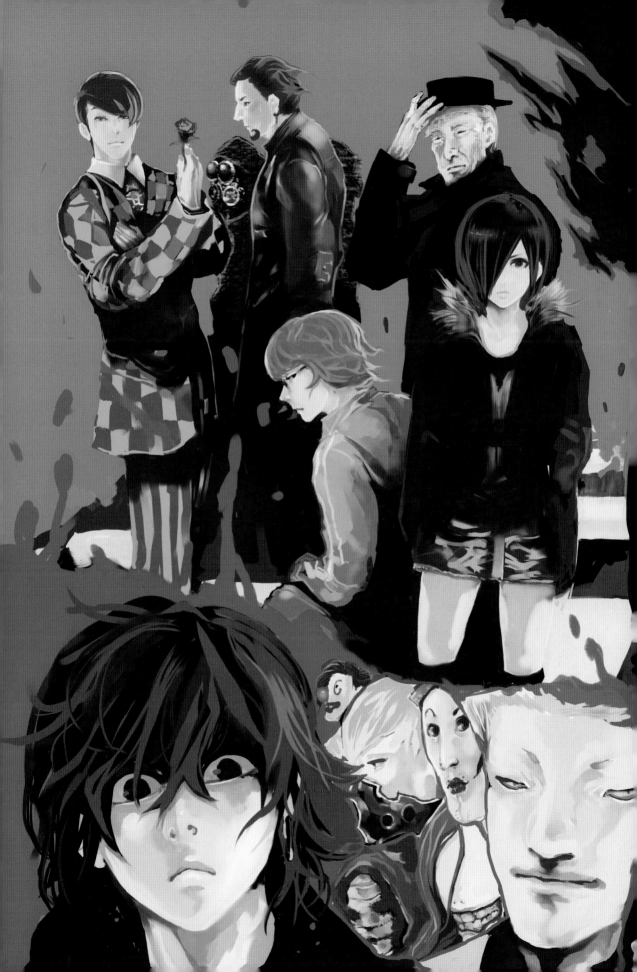

Chapter #063 [Ghoul] illustration.

This chapter resulted in a lot of
rejected color illustrations because
I wasn't sure of what to draw.

The chair Kaneki's sitting in is the
same chair from the cover of volume 1.

III

Young Jump 2013 ● No. 8
Title Page Color Illustration

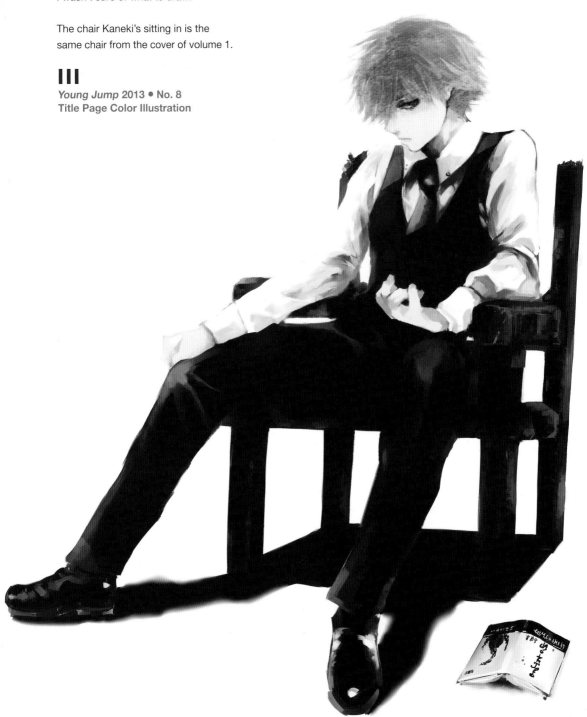

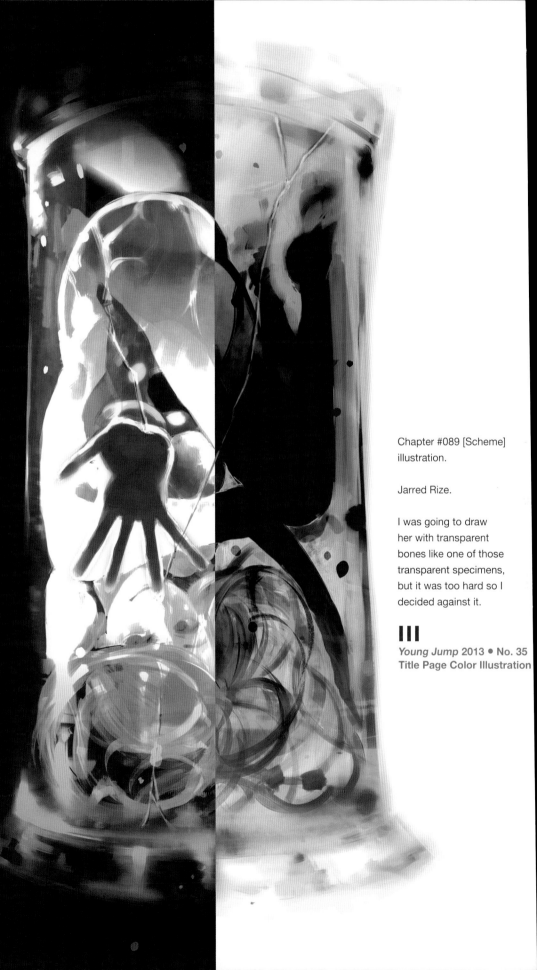

Chapter #089 [Scheme]
illustration.

Jarred Rize.

I was going to draw
her with transparent
bones like one of those
transparent specimens,
but it was too hard so I
decided against it.

▌▌▌
Young Jump 2013 • No. 35
Title Page Color Illustration

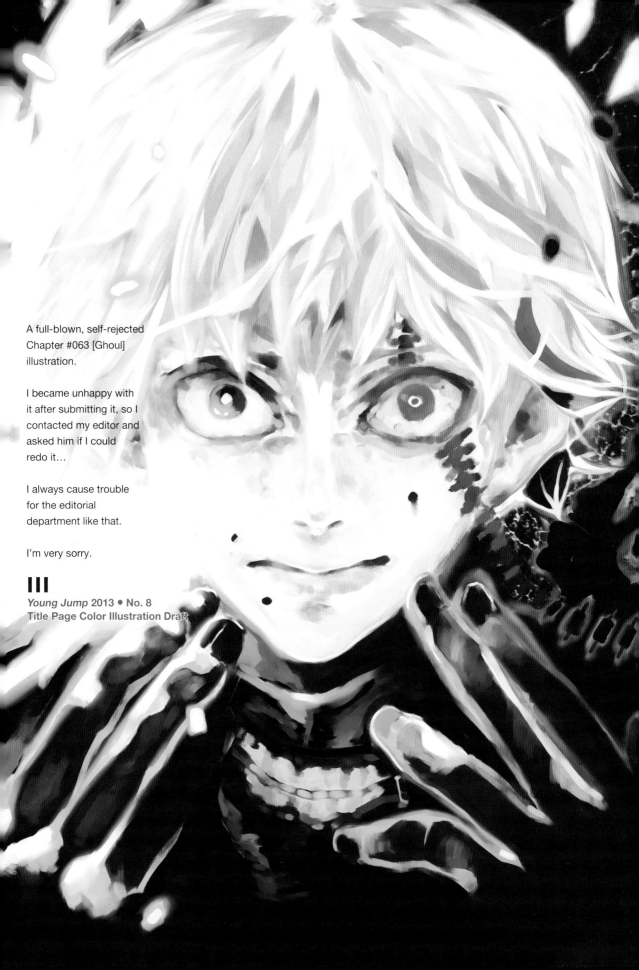

A full-blown, self-rejected
Chapter #063 [Ghoul]
illustration.

I became unhappy with
it after submitting it, so I
contacted my editor and
asked him if I could
redo it…

I always cause trouble
for the editorial
department like that.

I'm very sorry.

||| *Young Jump* 2013 ● No. 8
Title Page Color Illustration Draft

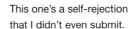

This one's a self-rejection
that I didn't even submit.

Kaneki falling.
I was hoping I could use it
somewhere, but it ended
up never being used.

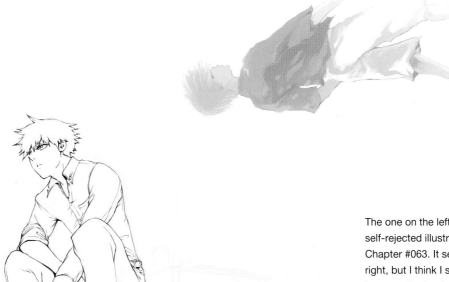

The one on the left is also a
self-rejected illustration for
Chapter #063. It seems all
right, but I think I stopped
because the background
would've been too difficult.

I was trying to remember
why I drew so many
rejected color illustrations
for Chapter #063 and
realized it was because the
chapter was about Kaneki
realizing he's a Ghoul.

I wonder what kind of color
illustration I would draw for
it now.

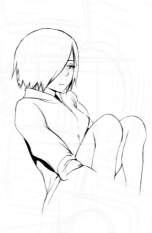

III
Young Jump 2013 • No. 8
Title Page Illustration Draft

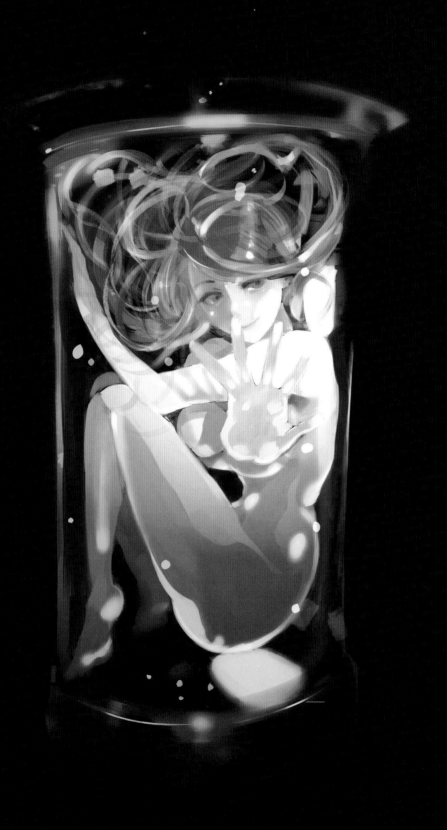

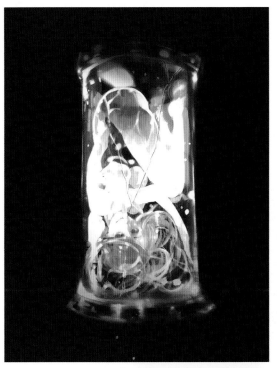

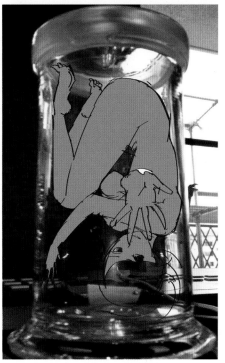

I wasn't sure how to render this image so I made a bunch of different versions and sent them to the editor so we could discuss them. Maybe the one without processing is good too because it's easier to see.

I drew her confined in a sketch first to visualize what that would look like for the more elaborate piece.

I was going to keep the jar for another use, but the heat or something broke it after I finished the illustration.

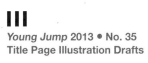

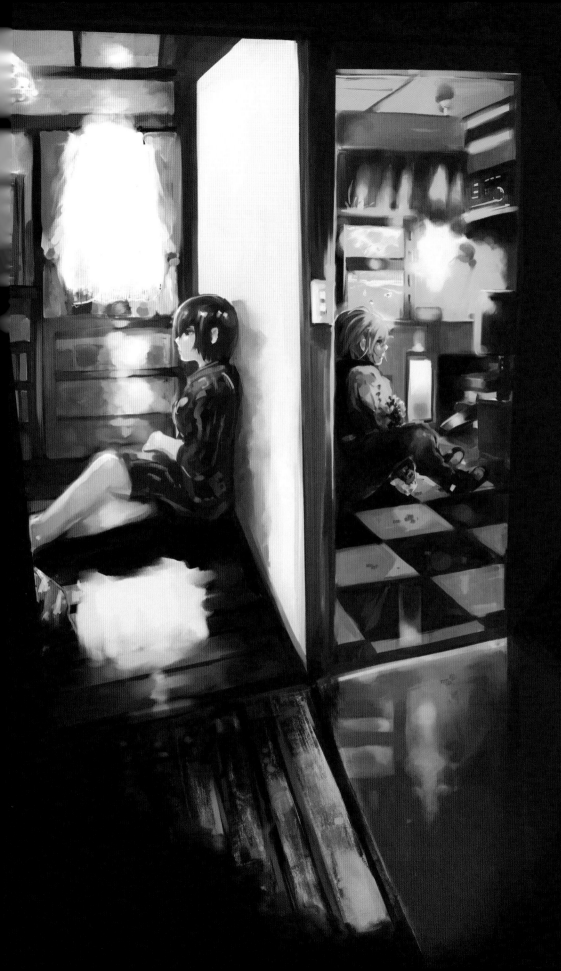

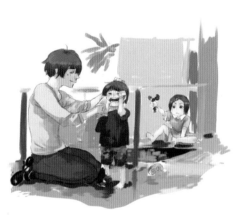

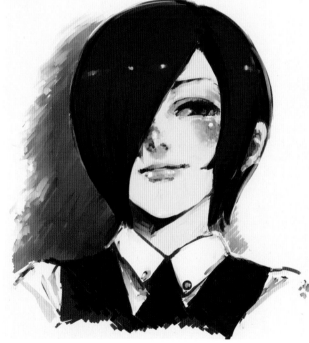

Chaptor #071 [Two Pooplo] titlo pago color illuctration.

I rejected a lot of illustrations myself before I even showed them to my editor. But looking back at the original versions now, I think they were still hinting at what I was trying to express.

III
Young Jump 2013 • No. 16 • Title Page Color Illustration

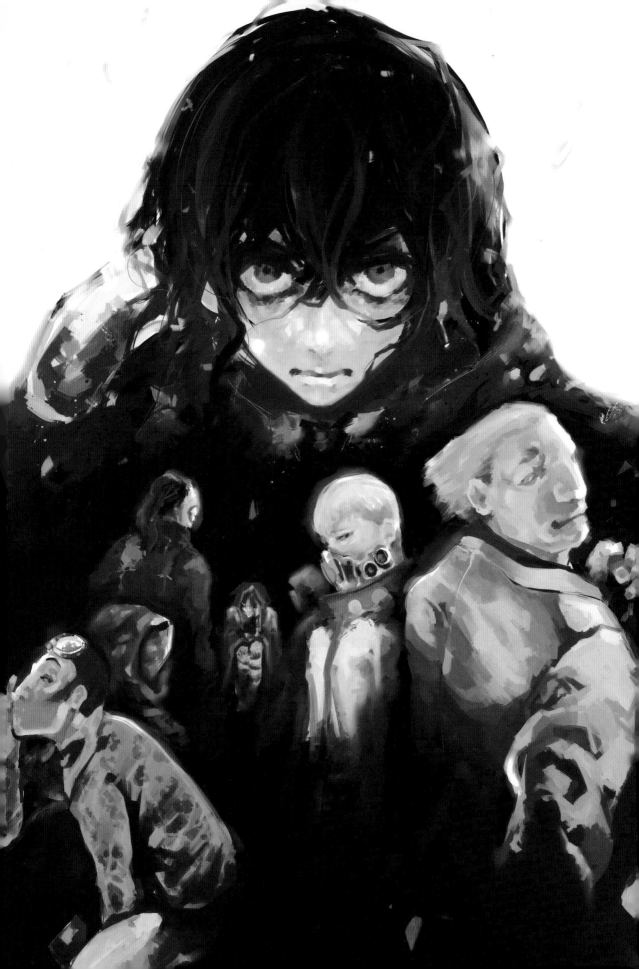

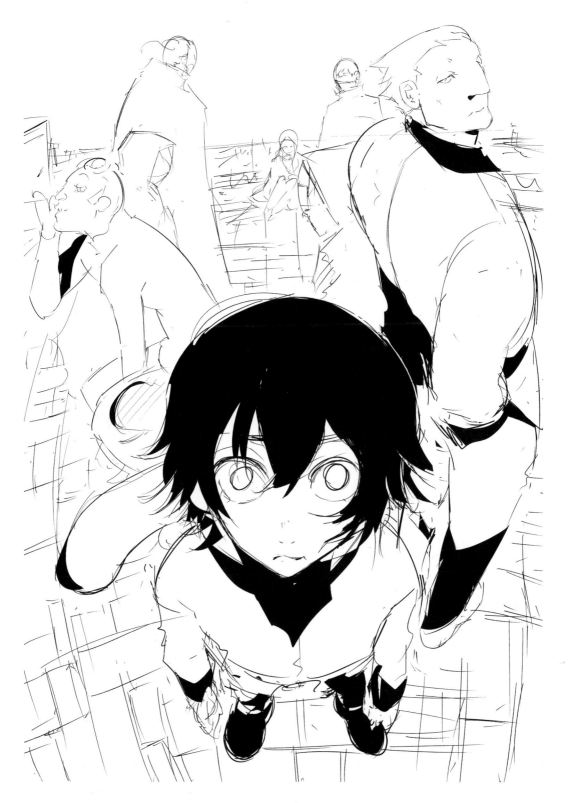

Chapter #075 [Secret] illustration.
Members of Aogiri Tree. I made this version with a different composition.
Maybe I changed it to the one on the right to make Ayato bigger?
I kept the line drawings of Yamori and Nico from the one above.

III

Young Jump 2013 • No. 20 • Title Page Color Illustration

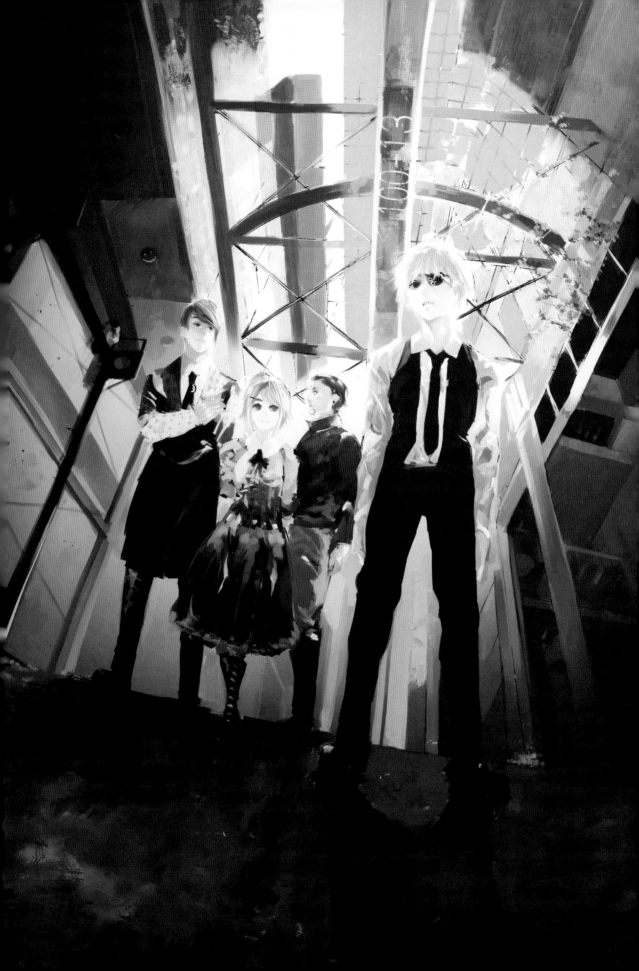

① **Line Drawing**

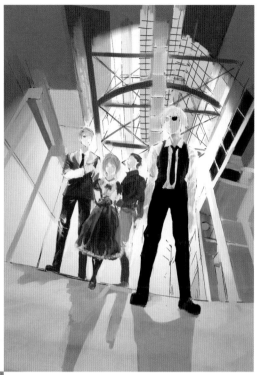

② **Rough Colors**

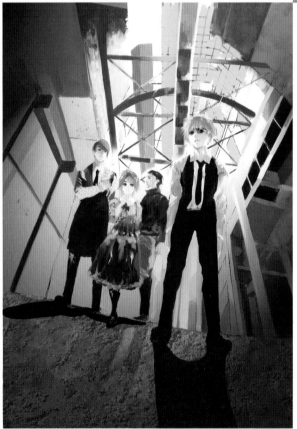

③ **Mid-process Colors**

Chapter #087 [Rumor] illustrations.

This is an illustration of the 6th Ward denizens. On a whim, I began saving progress drafts starting around this time.

I also started using different types of painting software. I used Comic Studio for the line drawing, and SAI and Painter to color it.

▌▌▌
Young Jump 2013 • No. 33
Color Study for Title Page

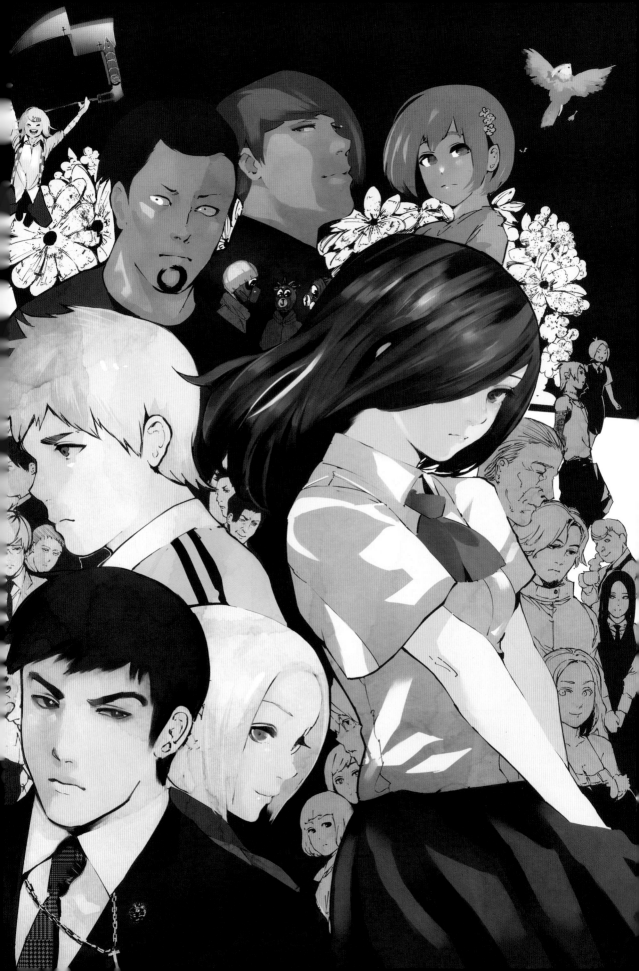

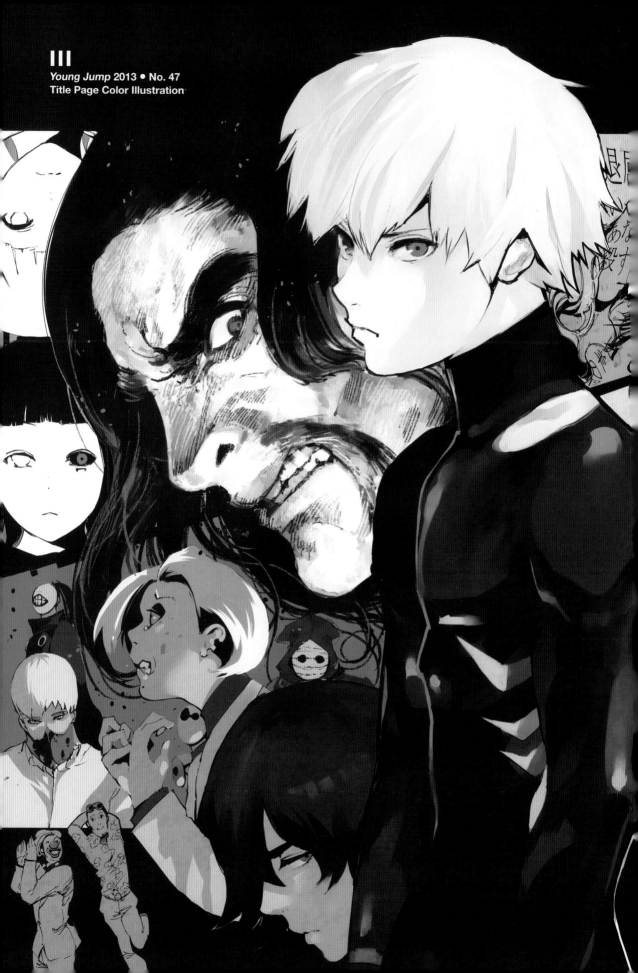

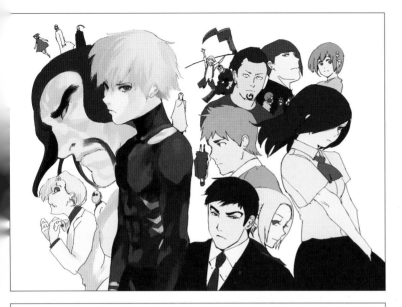

So I need to make a color illustration for chapter #100, huh...

All right, it's a milestone chapter and they're gonna use it for a poster too, so I'll make it a group illustration. I'll choose characters that are active in the story right now.

Shiro and Kuro, Shachi, and Naki are musts. I'll place officers of Aogiri on top of Shachi's head. Amon, Akira, and the Shinohara-Juzo pair for the CCG...

It'll also need the 6th Ward Kaneki Family.

I'll include Touka and Hide even though they're not really that active in this chapter.

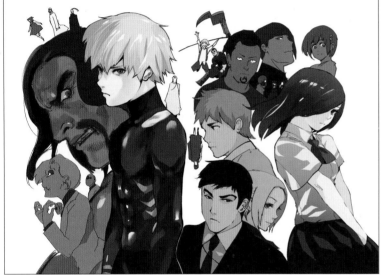

Rough colors.

Shachi's face is changing already.

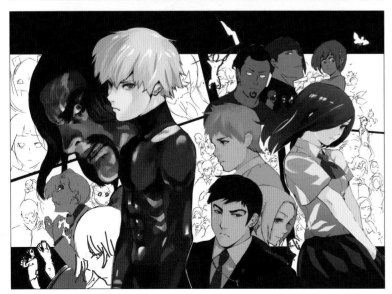

I won't put the Aogiri officers on his head. Shiro and Kuro should also be bigger...Might as well include Rize while I'm at it.

Oh, I forgot about Ayato.

Now I feel bad for the other characters...Anteiku, the CCG, and...I'll have Hetare flying, and the Clown too. Oh, there's no room for Nishiki.

Shachi's way more intense looking.

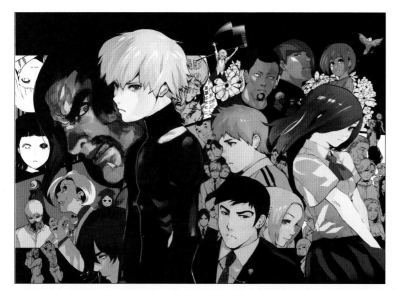

Shachi turns red.

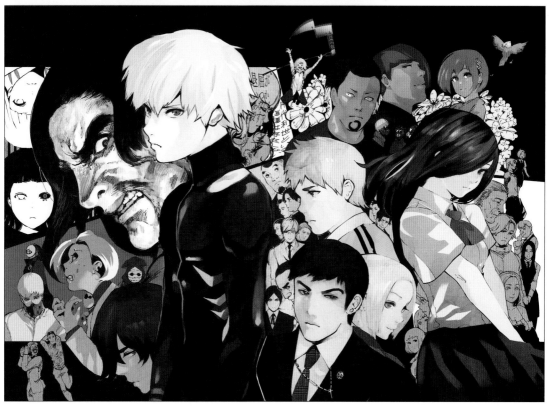

Shachi ends up looking completely different.
Done! (What's the point of planning ahead?)

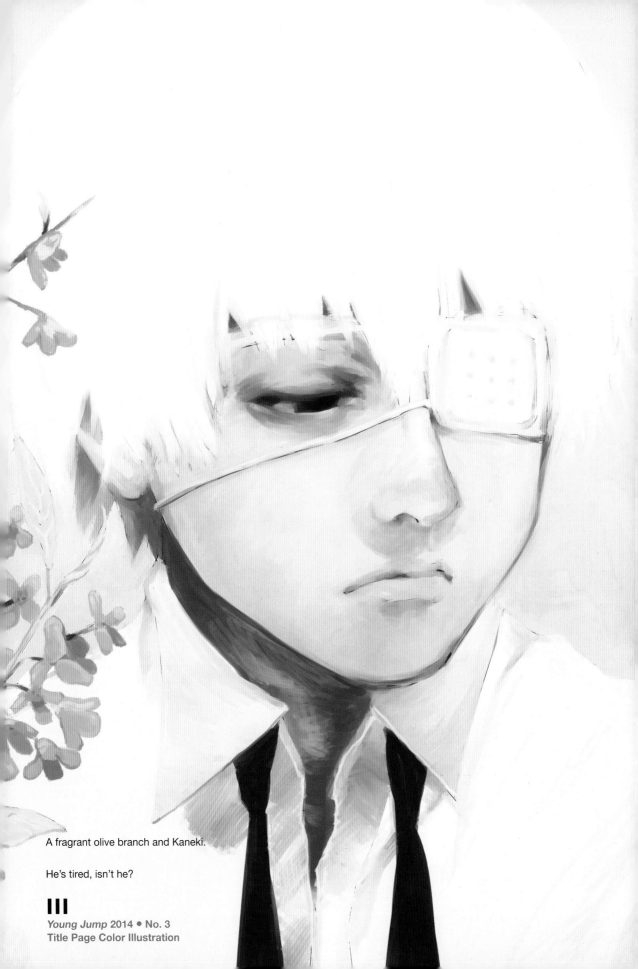

A fragrant olive branch and Kaneki.

He's tired, isn't he?

A young Yomo and Uta.

This must be the shirt that Itori says Yomo's been wearing forever...

III

Young Jump 2014 • No. 3
Title Page Color Illustration

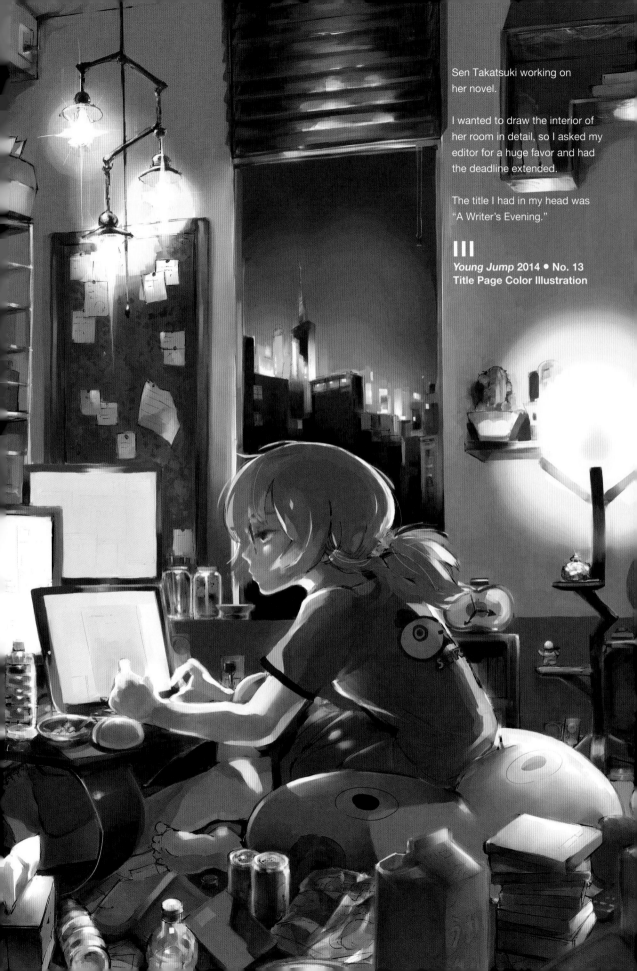

Sen Takatsuki working on her novel.

I wanted to draw the interior of her room in detail, so I asked my editor for a huge favor and had the deadline extended.

The title I had in my head was "A Writer's Evening."

III
Young Jump 2014 ● No. 13
Title Page Color Illustration

Chapter #119 [Antique] illustration.

I think the angle is good.

I forgot what was going on here though.

|||

Young Jump 2014 ● No. 16
Title Page Color Illustration

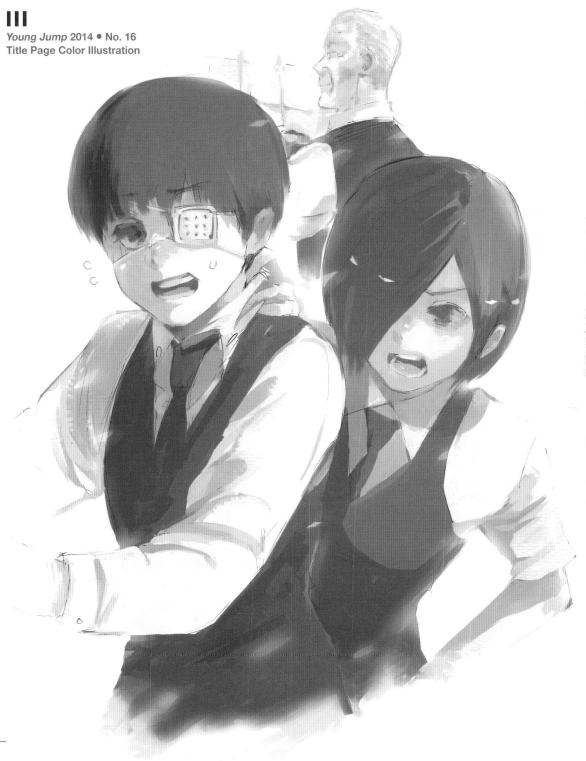

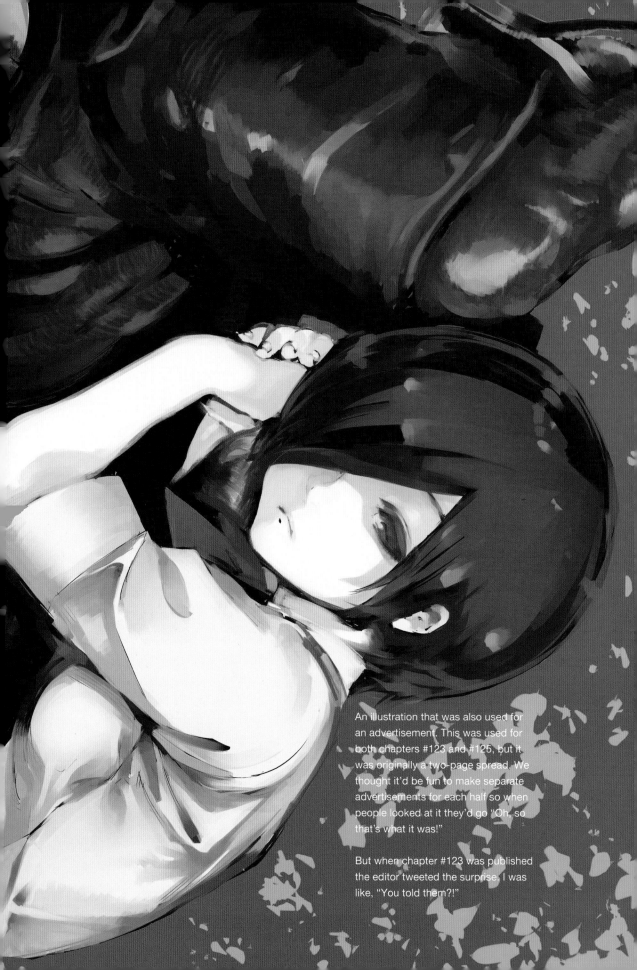

An illustration that was also used for an advertisement. This was used for both chapters #123 and #125, but it was originally a two-page spread. We thought it'd be fun to make separate advertisements for each half so when people looked at it they'd go "Oh, so that's what it was!"

But when chapter #123 was published the editor tweeted the surprise. I was like, "You told them?!"

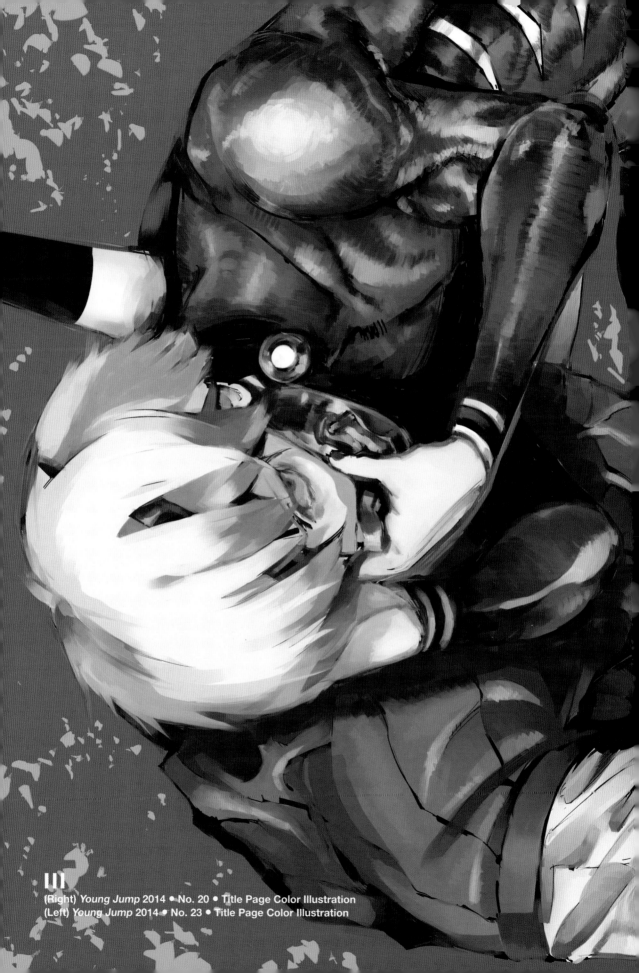

The friends in Kaneki's head.

Rize's whispering to Kaneki "Now what should we do, Kaneki?"

He's still sitting on the broken chair.

|||
***Young Jump* 2014 • No. 31**
Title Page Color Illustration

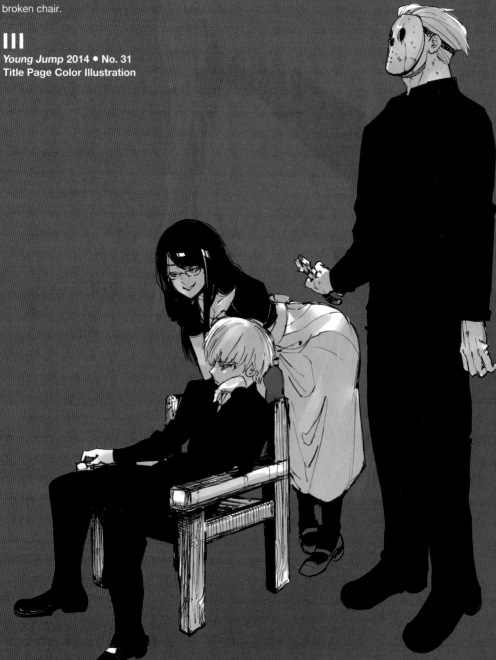

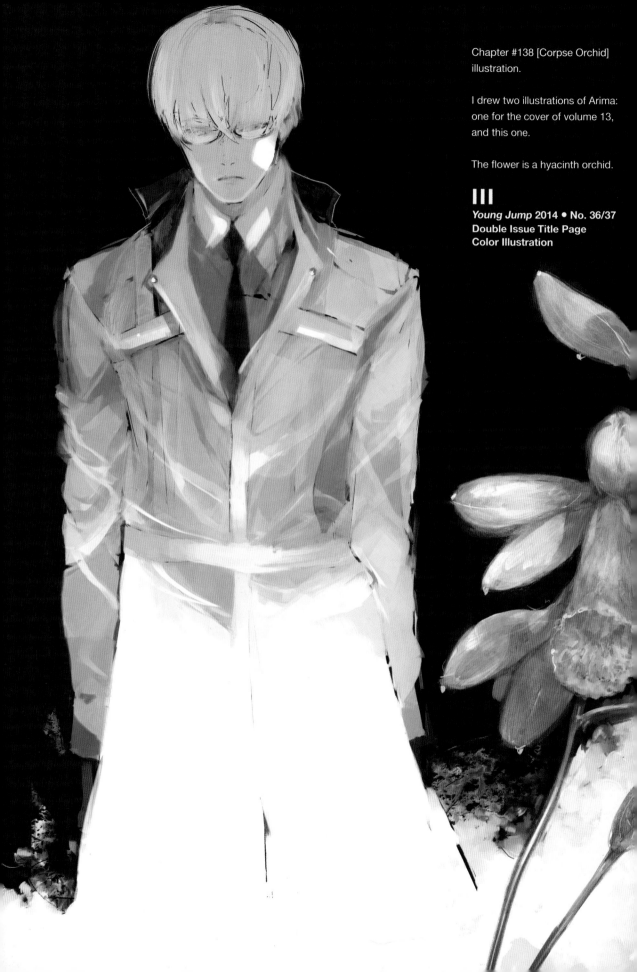

Chapter #138 [Corpse Orchid]
illustration.

I drew two illustrations of Arima:
one for the cover of volume 13,
and this one.

The flower is a hyacinth orchid.

III
Young Jump 2014 ● No. 36/37
**Double Issue Title Page
Color Illustration**

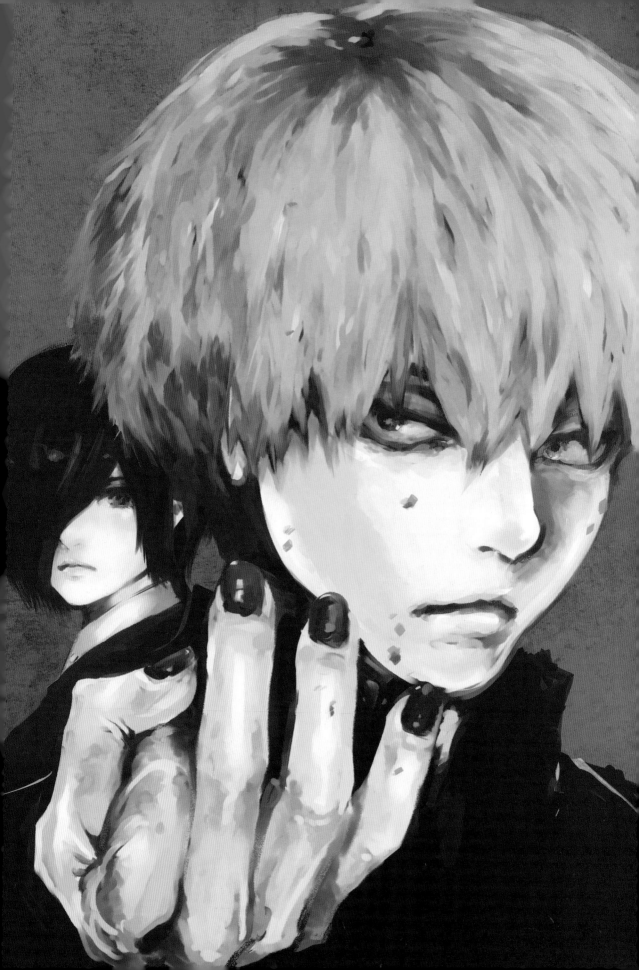

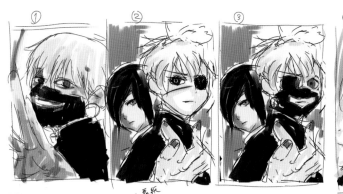

III
(Right Page)
Young Jump 2013 ● No. 16
Cover
(Left Page, Bottom Right)
Young Jump 2014 ● No. 3
Cover
(Left Page, Bottom Left)
Young Jump 2014 ● No. 24
Cover

Drafts for a *Young Jump* cover illustration.

It was my first time drawing a cover for a magazine. I drew thumbnails and had the editorial department pick one they liked, which was the eye patch-less version of No. 2.

No. 4 could've been interesting too.

The two on the bottom are for a *Young Jump* group illustration. The one on the right ran with *Kingdom* and *Terra Formars* so I drew a Terraformar on the cup. Maybe in response to that, Ken-ichi Tachibana drew Kachi-Kachi on his illustration…I kind of chuckled to myself.

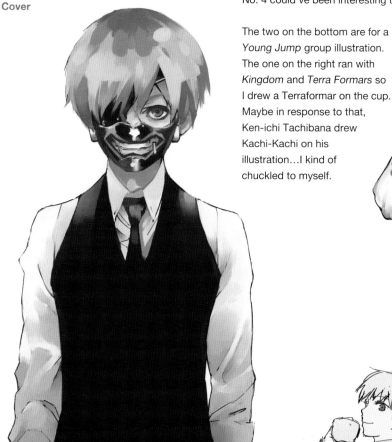

A sketch of the one on the right. I think I changed the direction he's facing due to the arrangement of the group illustration.

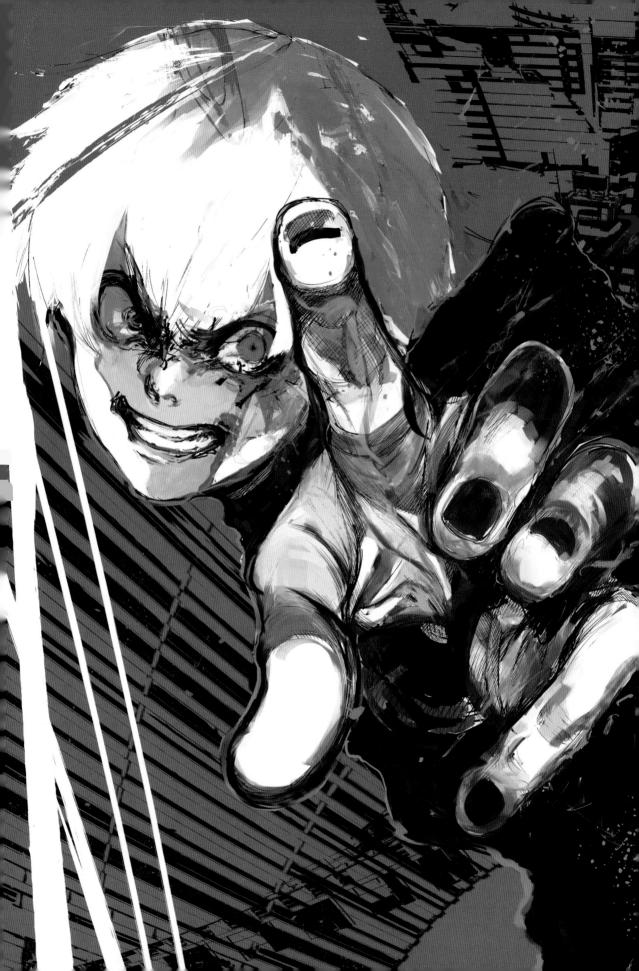

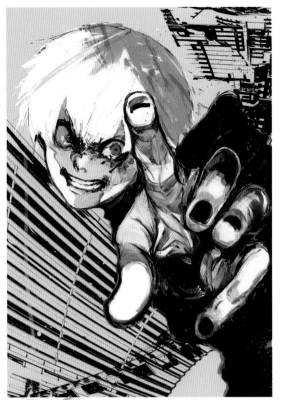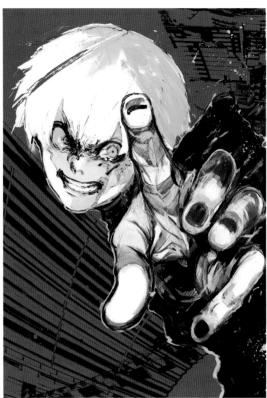

My second *Young Jump* cover.

It might've been the issue from the week the anime started?

I decide on a color pattern once I'm done drawing most of the image. I usually end up going with red.

I was going to go with a yellow background, but I thought red would stand out more so I went with that.

| | |

Young Jump 2014 • No. 31
Cover

I went with these four because I wanted
an illustration featuring only female characters.
I also used a different method of coloring.

III

Young Jump Special Newcomer Issue
Young Jump Seed 2013 ● No. 11 ● Bonus Art

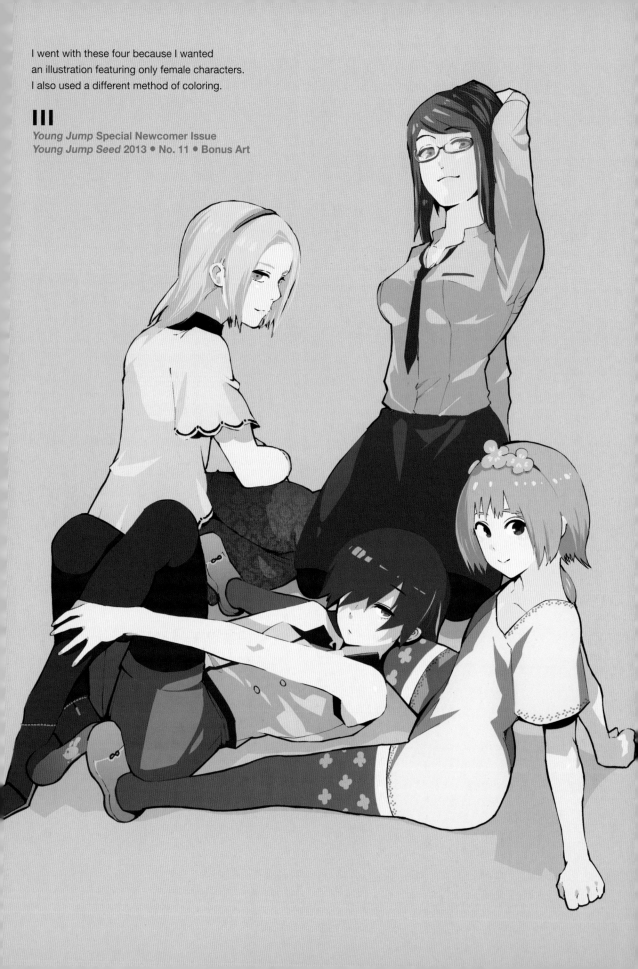

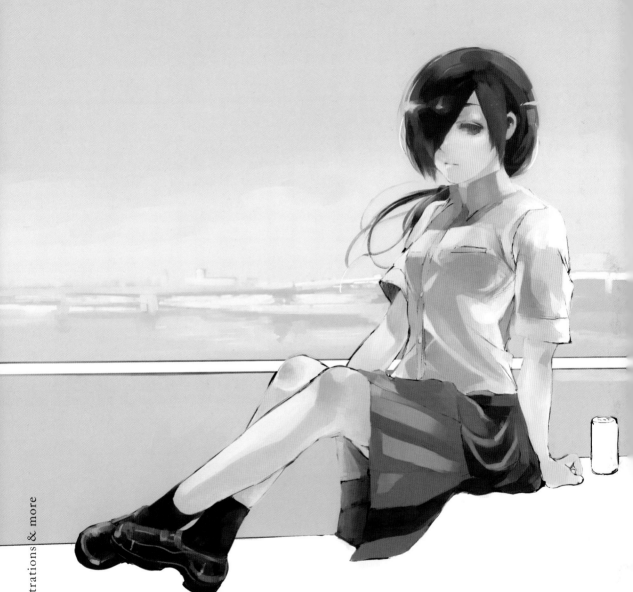

A *Miracle Jump* cover.

I wanted to capture the feeling of summer.

III
Young Jump Special Issue
Miracle Jump 2014 ● July ● Cover

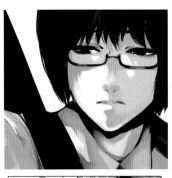

Cover for *Tokyo Ghoul: Jack*.

It was a spin-off of *Tokyo Ghoul* that ran in an online manga app called *Jump Live* in the summer of 2013.

It's about Ghoul Investigator Kisho Arima in high school, and his partner, Taishi Fura, who makes a brief appearance in the main story too.

The main story was still ongoing, so after I finished that, I would work on *Tokyo Ghoul: Jack*. Once I was done with that I would go back to working on the main story again. That's how I spent that August…

I did all the work by myself, so it was nice being able to work on it on my own time.

The rough style of art also helped make it easier.

Jump Live • No. 1 • 2013

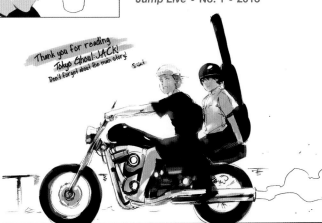

Thank you for reading Tokyo Ghoul: JACK! Don't forget about the main story! Sui

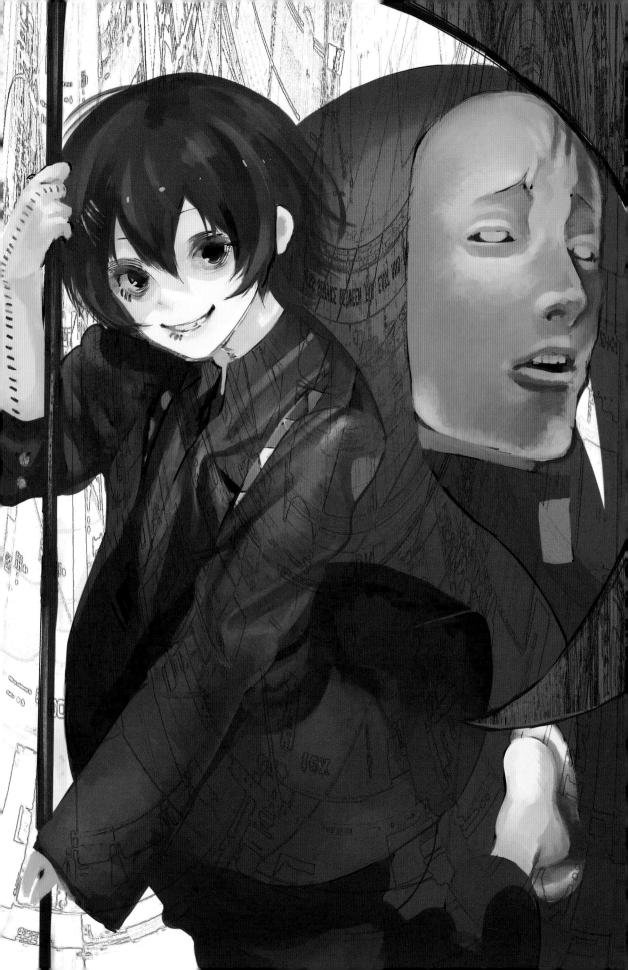

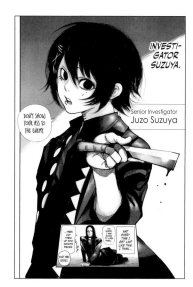

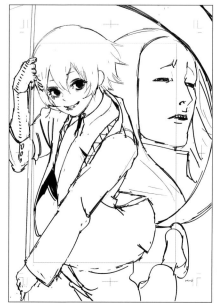

Cover of *Tokyo Ghoul: Joker*.

A one-shot that ran not in *Young Jump*, but in *Weekly Shonen Jump* in 2014.

It's about Juzo Suzuya and his subordinate Hanbe Ahara.

It was an honor to have my work appear in the same magazine as Yoshihiro Togashi's.

III

Weekly Shonen Jump
No. 31 • 2014

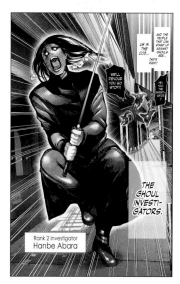

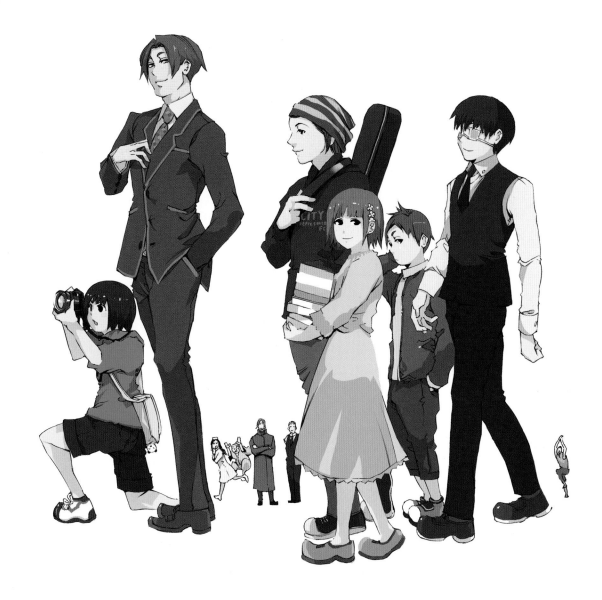

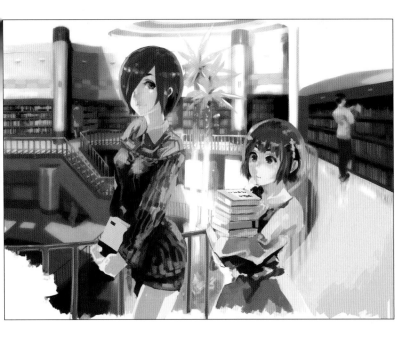

Above is the cover illustration for *Tokyo Ghoul: Days*, one of the *Tokyo Ghoul* novels.

I wanted to try a different look, so I went with a solid, high-contrast style. Hide's green jacket was brighter and more fluorescent, but it didn't come out that way in print.

The Rubik's Cube is my favorite part about this one.

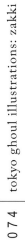

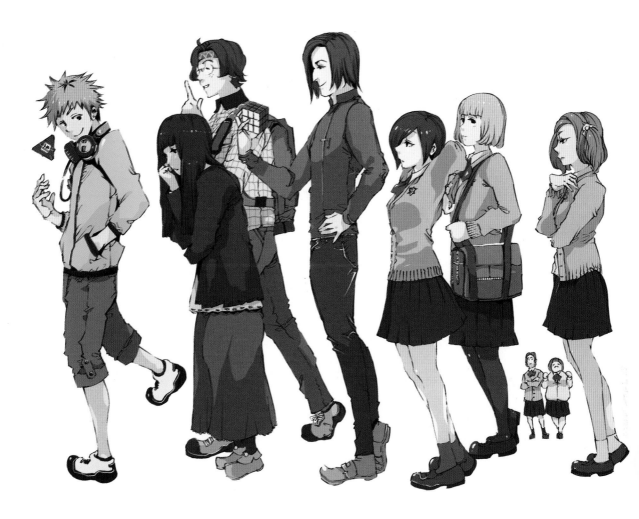

On the right are the images for the fold-out color insert in *Tokyo Ghoul: Days*.

It's my reattempt at the black-and-white feel I tried doing for the color illustration of chapter #026 [Adversary].

III
2013
Tokyo Ghoul: Days
Novel Cover/
Color Insert

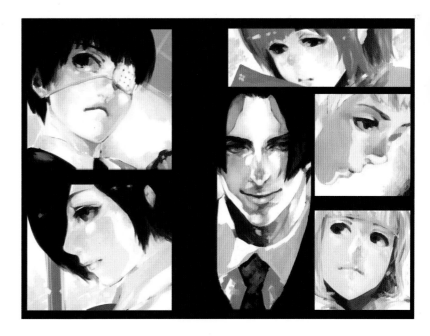

The solid, high-contrast look I used for the cover of *Tokyo Ghoul: Days* didn't sit well with me, so for *Tokyo Ghoul: Void* I chose to go with a tone that was in between my usual method and a more crisp style.

Visually, I like Morimine. Chiehori is photographing Kaneki's butt. Like I mentioned earlier, Chiehori is a character from work I submitted in the past, so I have a special attachment to her. I explained her character to the novel writer Shin Towada and had him include her in the book. I went through all the lines and dialogue in the novels and even changed some here and there.

Towada really understood the idea behind the main story and wrote all kinds of storylines for each character. I simply marveled at what he came up with.

III
2014 ● *Tokyo Ghoul: Void* Novel
Cover/Color Insert

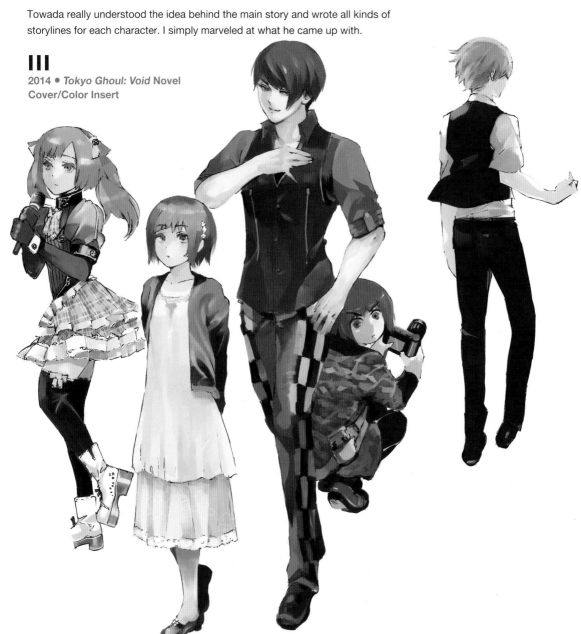

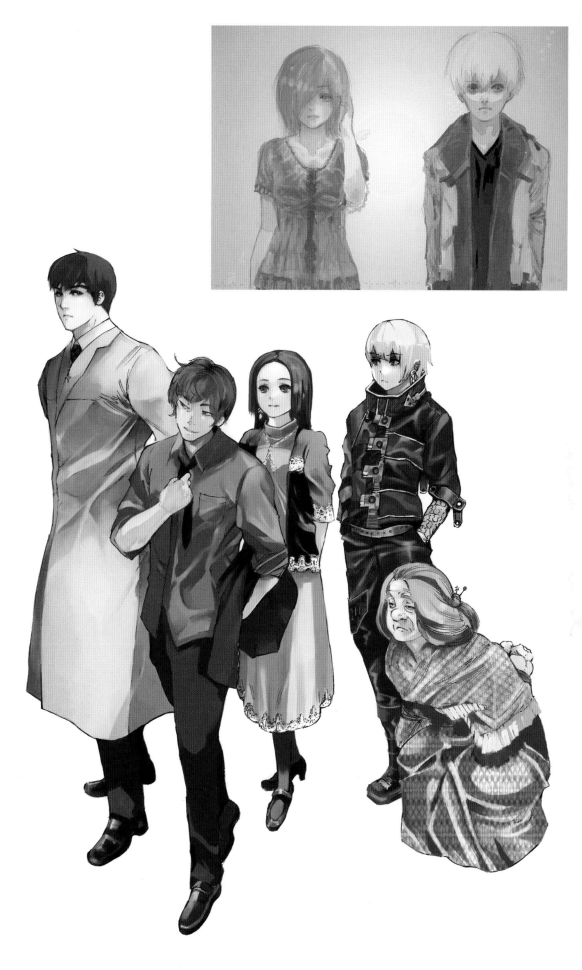

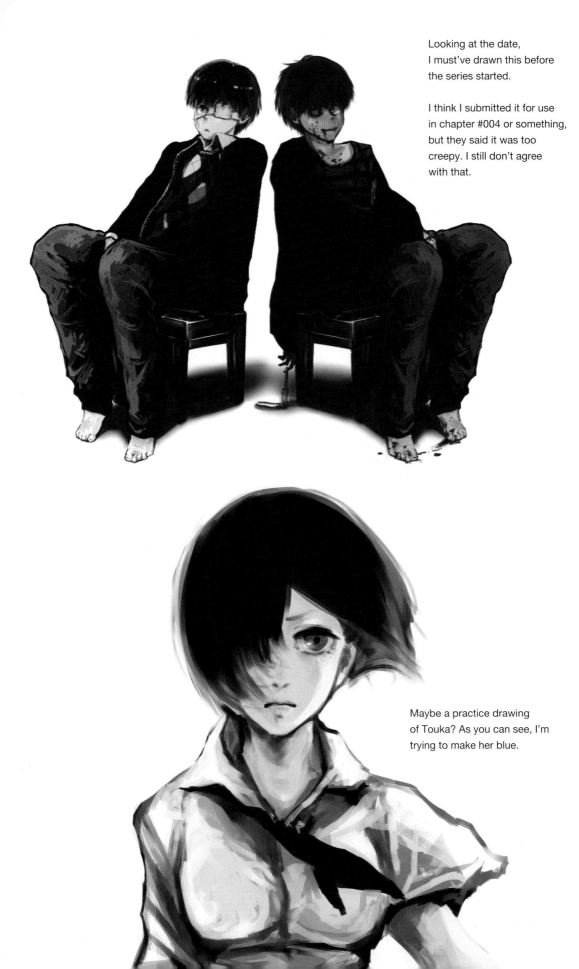

Looking at the date,
I must've drawn this before
the series started.

I think I submitted it for use
in chapter #004 or something,
but they said it was too
creepy. I still don't agree
with that.

Maybe a practice drawing
of Touka? As you can see, I'm
trying to make her blue.

Juzo

- Round eyes
- Bags under eyes
- Scruffy hair

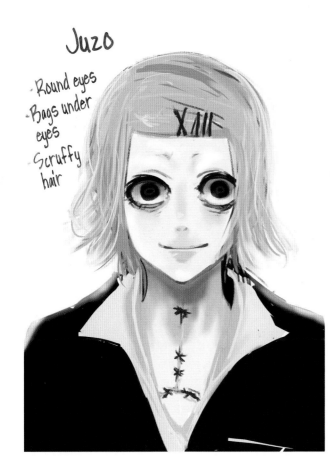

A rough illustration of Juzo. I drew these before his appearance. These must be studies to capture his character image.

I storyboarded several versions of *Tokyo Ghoul* before settling on the final one that was published. In one of those versions he appears as Ghoul Investigator Suzuya with Shinohara.

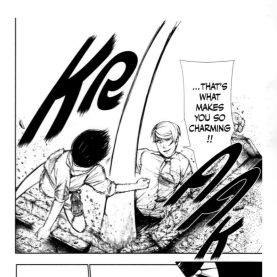

...THAT'S WHAT MAKES YOU SO CHARMING!!

I also drew him in the Tsukiyama arc.

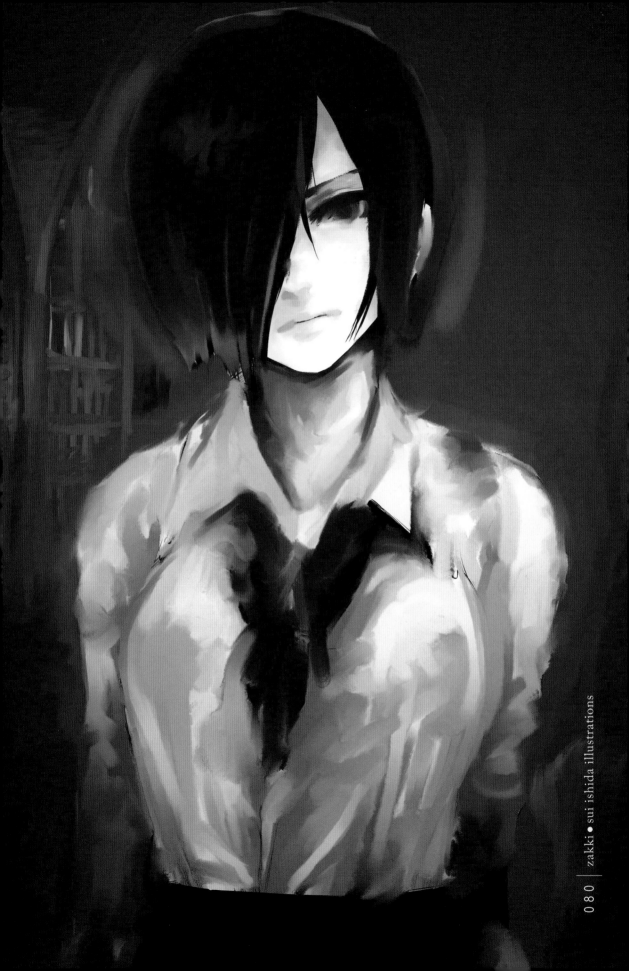

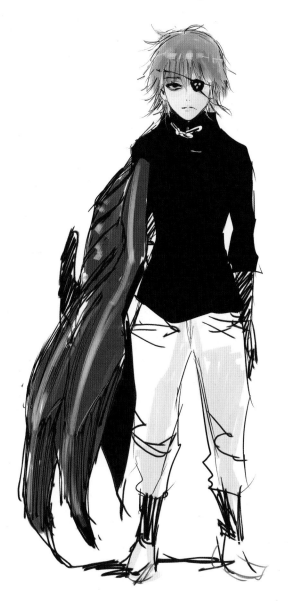

(Right)
This one was another rejected piece for chapter #071. I drew it rather painstakingly, so it ended up being large.

(Left)
A study. Looking at the file name, it must be an illustration for chapter #050.

(Below)
A doodle.

(Bottom left)
I'm pretty sure that's a sketch for a bookstore postcard, possibly around volume 7? It's too cramped, so I nixed it. Looking at its composition, I get the feeling it was reused for the color illustration on pages 60–61.

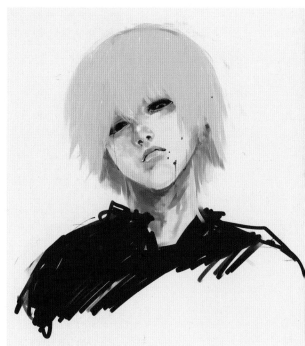

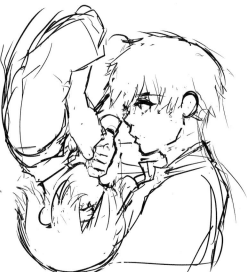

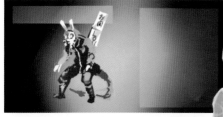

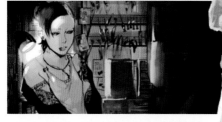

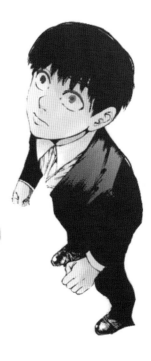

There's going to be a *Tokyo Ghoul* video game! Images used for an April Fool's Day hoax.

I was right up against the deadline for the main story, but I studied Flash from scratch and finished the project without sleeping for twenty-four hours. The images were unveiled on April 1.

A private project that made my editor shudder…

I was almost weeping when I worked later on the main story. I got what I deserved. I deeply regretted it…

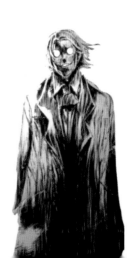

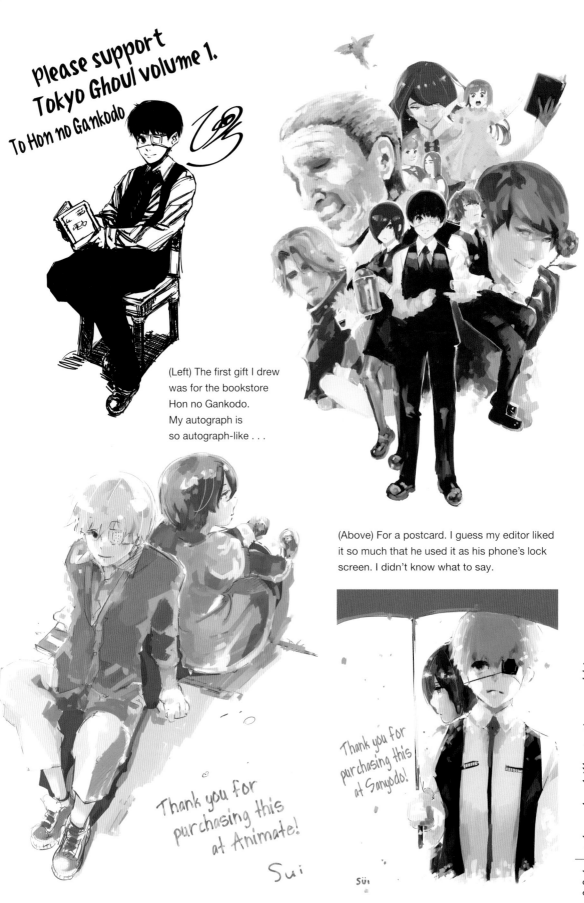

please support
Tokyo Ghoul volume 1.
To Hon no Gankodo

(Left) The first gift I drew
was for the bookstore
Hon no Gankodo.
My autograph is
so autograph-like . . .

(Above) For a postcard. I guess my editor liked
it so much that he used it as his phone's lock
screen. I didn't know what to say.

Thank you for
purchasing this
at Animate!

Sui

Thank you for
purchasing this
at Sanyodo!

sui

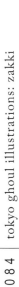

Thank you for purchasing this at Tora no Ana!

Thank you for purchasing this at Tora no Ana!

Touka reluctantly wearing a costume.

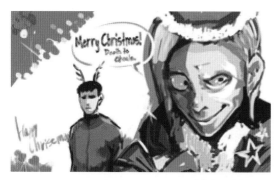

Merry Christmas! Death to Ghouls.

Merry Christmas!

Happy Halloween

Thank you for purchasing this at Animate!

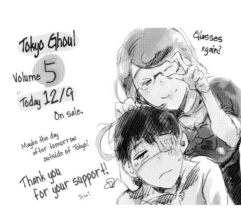

Tokyo Ghoul

Volume 5

Today 12/9

On sale.

Maybe the day after tomorrow outside of Tokyo?

Thank you for your support!

Glasses again?

• Includes a one-shot of Rize. (It's from a while back so the art is a bit...)
• 6 bonus pages
• Some kind of giveaway contest on the obi. Supposedly.

Tokyo Ghoul is the first color title on Young Jump going on sale tomorrow. Check it out...

Thank you for purchasing this at Tora no Ana!

Hinami looking good in a costume.

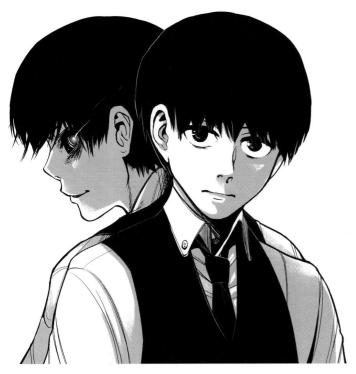

(Above) Preview cuts before serialization. The one on the right was rejected and the one on the left was used, I think…

Possibly for character development? Judging from the file name, I think it's an illustration for chapter #035.

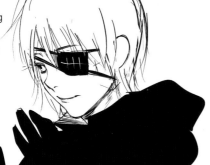

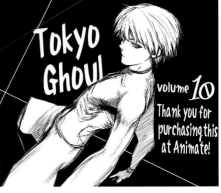

Thank you for purchasing this at Tora no Ana!

A four-panel comic I tweeted. I must've had a lot of spare time.

Sometimes I make some strange mistakes.

Because somebody said it was Pocky Day.

Pocky

2/4

NISHIKI NISHIO

Sure. It's summer vacation every day for me.

Naki

Tokyo Ghoul

Please purchase volume 2.

← These people are in it.

...and where Kaneki looks tasty.

Please purchase volume 4 that I star in...

Tsukiyama once again with a magatama bead-like haircut.

Thank you for your support. Ishida

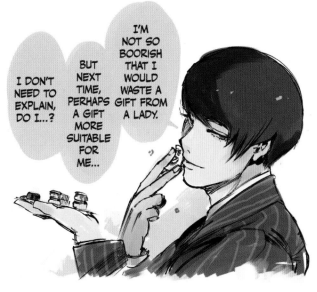

I DON'T NEED TO EXPLAIN, DO I...?

BUT NEXT TIME, PERHAPS A GIFT MORE SUITABLE FOR ME...

I'M NOT SO BOORISH THAT I WOULD WASTE A GIFT FROM A LADY.

I laughed when I got mail for Shu Tsukiyama that had "Tsuki" in the address field. I guess Tsukiyama could live on the moon if he wanted.

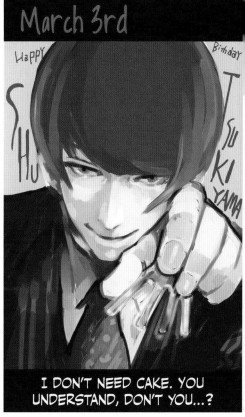

March 3rd

Happy Birthday

SHU TSUKIYAMA

I DON'T NEED CAKE. YOU UNDERSTAND, DON'T YOU...?

Tsukiyama's birthday. I drew three of these in one day. He received illustrations, clay models, and candy from readers. He's a very lucky man.

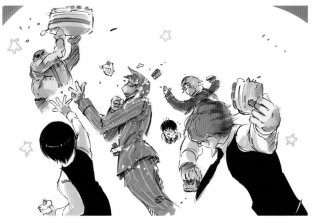

December 20 is... kaneki's birthday! HAPPY Birthday!

Kaneki's at his best when he's being tormented by Touka.

Merry Christmas

HAPPY ?

Tokyo Ghoul 2012/12/25 Sui

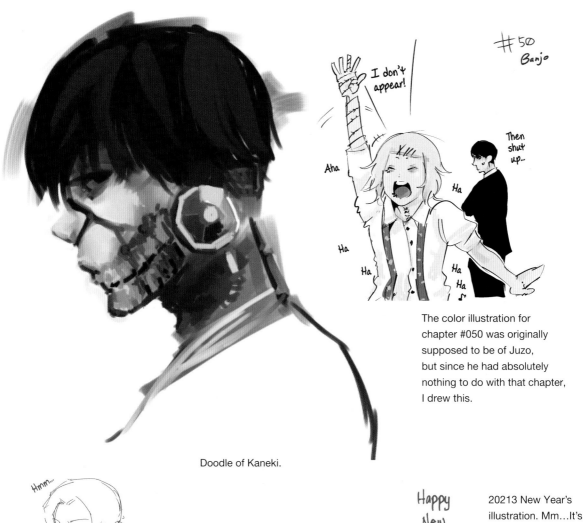

Doodle of Kaneki.

I don't appear!

Aha

Then shut up...

Ha

Ha

Ha

Ha Ha

The color illustration for chapter #050 was originally supposed to be of Juzo, but since he had absolutely nothing to do with that chapter, I drew this.

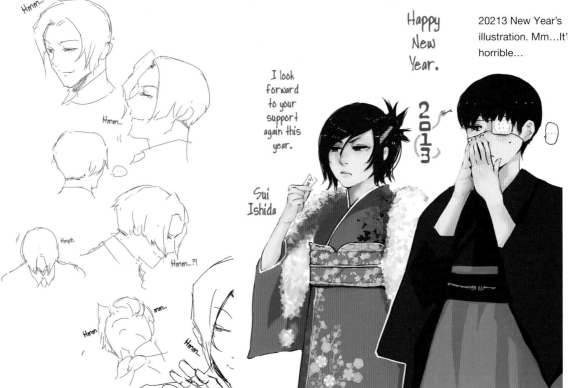

Hmm...

Hmm...

Hmm...

Hmph.

Hmm...?!

mm...

Hmm

Hmm...

Happy New Year.

20213 New Year's illustration. Mm...It's horrible...

I look forward to your support again this year.

Sui Ishida

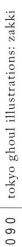

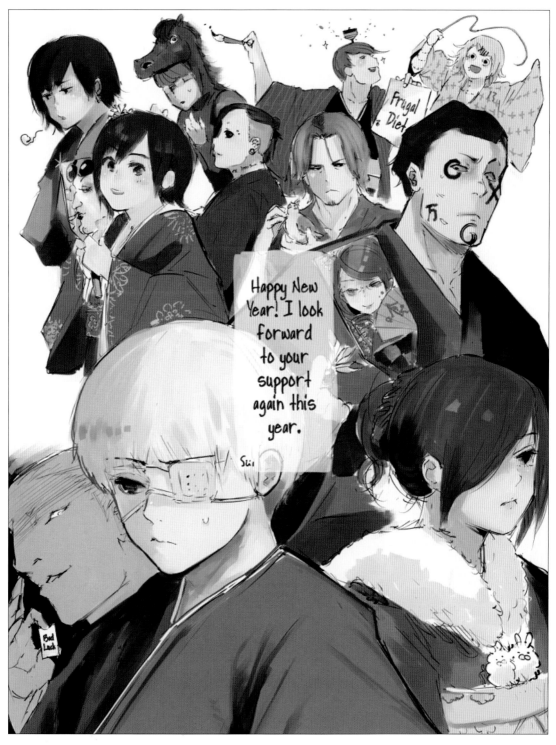

2014 New Year's illustration.

I streamed myself drawing this one
like Atsushi Nakayama did. I think
I streamed it for about 2½ hours. It
was a nerve-racking experience.

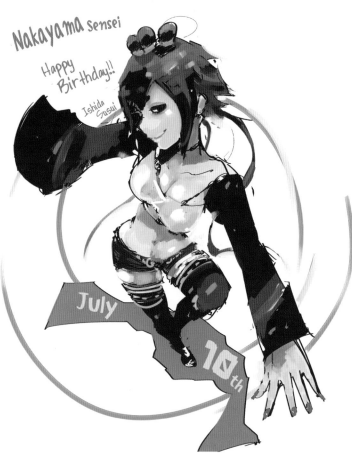

Nakayama sensei
Happy Birthday!!
Ishida Sushi

July
10th

This is a personal illustration of Maburu I drew for Atsushi Nakayama's birthday.

A lot of my characters are quite plain. I once again realized how brilliant Atsushi Nakayama's characters were as I drew it.

She's stylish and fun to draw. Mr. Nakayama, thank you for being born.

Another personal illustration I drew for the last chapter of *Nejimaki Kagyu*.

Atsushi Nakayama is an artist I admired for his distinctive style even before *Nejimaki Kagyu* was published.

He is such a soft-spoken and charming man in person. But he also has a bit of a crazy side to him. Much love and respect to him.

His work contains ways of expressing things that I would never think of. It's always inspired me.

It was sad to see *Nejimaki Kagyu* end, but I'm glad we got to be in *Young Jump* together…!

Nakayama Sensei
Thanks for all your hard work
On the Nejimaki Kagyu series!

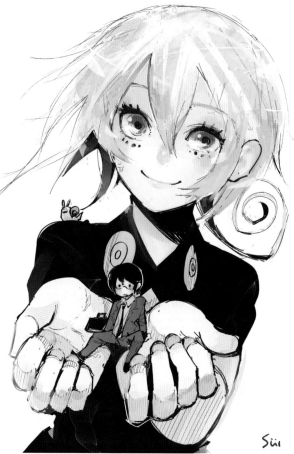

Sui

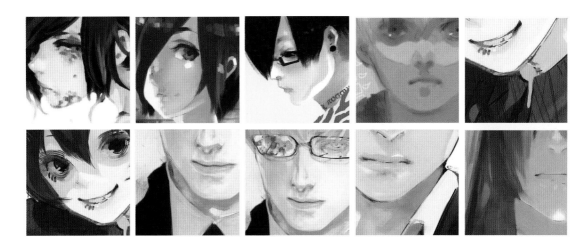

Illustrations I used as my Twitter icon.
I think I used Touka from the early days
for quite a while. Later on I chose icons
as sneak previews of yet-to-be-released
color illustrations.

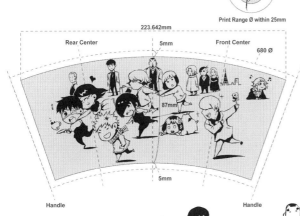

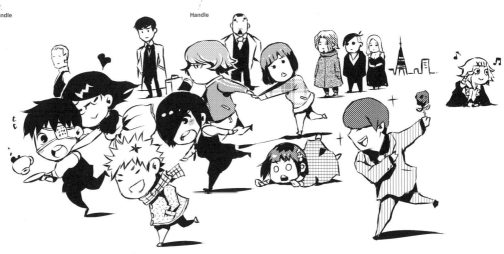

Illustration for a gift mug.
Lively with lots of mini characters.
Don't think we made that many…
I think it's a rare item.

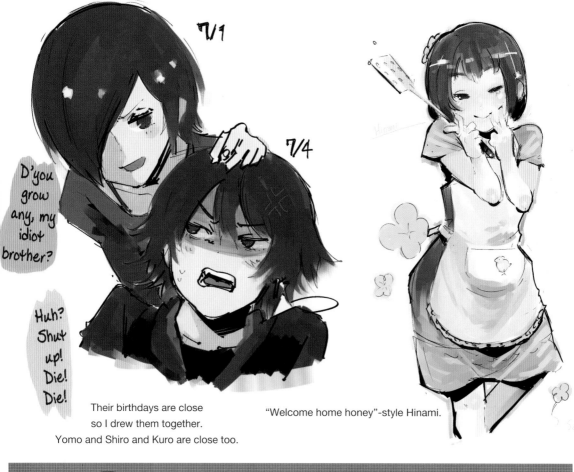

7/1

7/4

D'you grow any, my idiot brother?

Huh? Shut up! Die! Die!

Their birthdays are close so I drew them together.
Yomo and Shiro and Kuro are close too.

"Welcome home honey"-style Hinami.

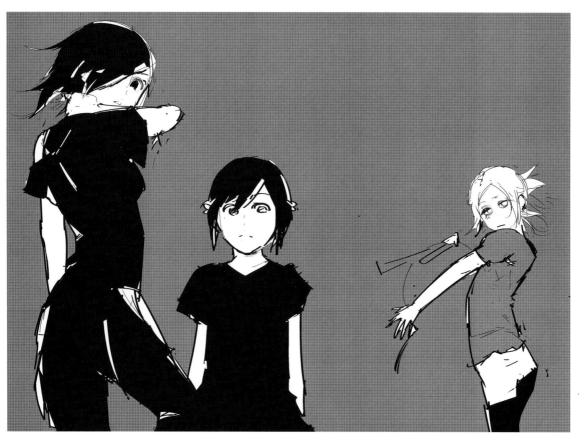

A rough sketch I drew for the illustration of the four girls for *Miracle Jump*. On the right is Juzo.

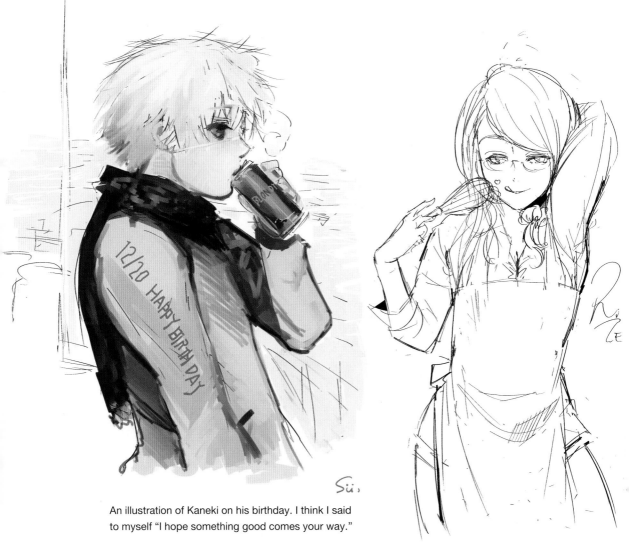

An illustration of Kaneki on his birthday. I think I said to myself "I hope something good comes your way."

Rize would never cook.

Sorry, Nishiki. Did you wait long?!

A tragedy.

Oh...

Dog poop.

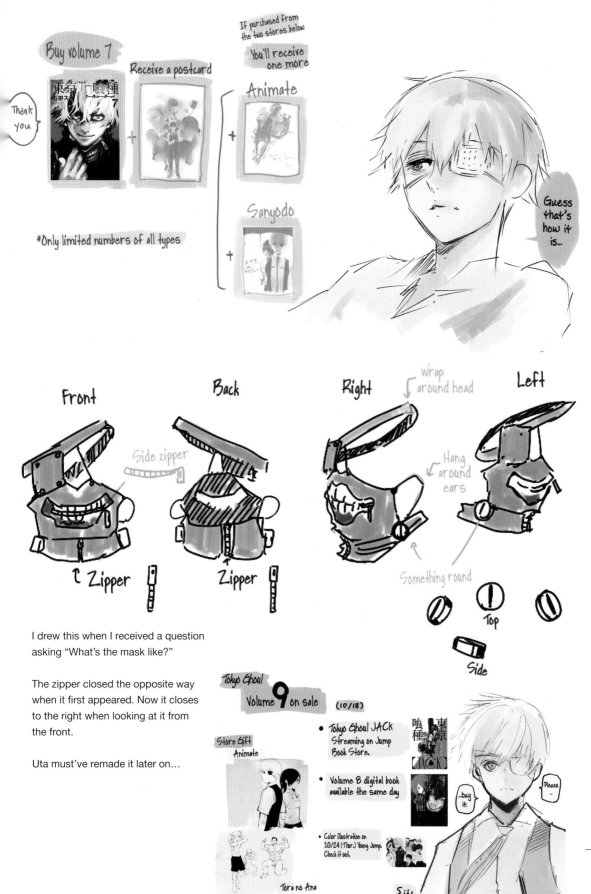

Buy volume 7

Thank you

Receive a postcard

If purchased from the two stores below

You'll receive one more

+ Animate +

+ Sanyodo +

*Only limited numbers of all types

Guess that's how it is...

Front

Back

Side zipper

Zipper

Zipper

Right

Wrap around head

Left

Hang around ears

Something round

Top

Side

I drew this when I received a question asking "What's the mask like?"

The zipper closed the opposite way when it first appeared. Now it closes to the right when looking at it from the front.

Uta must've remade it later on...

Tokyo Ghoul

Volume 9 on sale (10/18)

Store Gift
Animate

- Tokyo Ghoul JACk Streaming on Jump Book Store.

- Volume 8 digital book available the same day

- Color illustration on 10/24 (Thur.) Young Jump. Check it out.

Tora no Ana

...buy it.

Please -

Sui

096 | tokyo ghoul illustrations: zakki

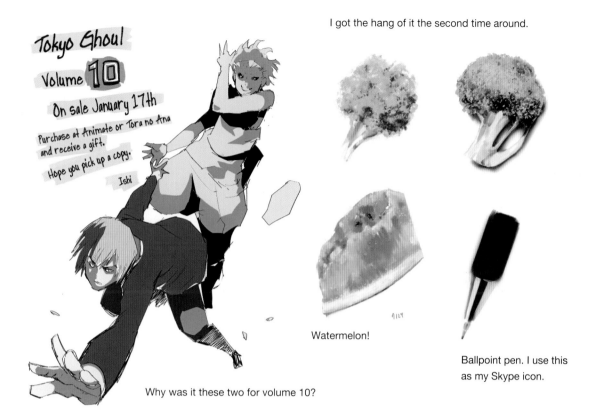

Tokyo Ghoul
Volume **10**

On sale January 17th

Purchase at Animate or Tora no Ana
and receive a gift.

Hope you pick up a copy.

Ishi

I got the hang of it the second time around.

Watermelon!

Ballpoint pen. I use this
as my Skype icon.

Why was it these two for volume 10?

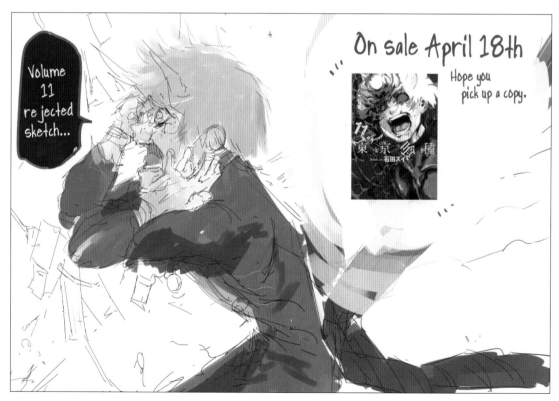

Volume
11
rejected
sketch...

On sale April 18th

Hope you
pick up a copy.

Volume 11's rejected sketch + volume 11 promotional illustrations. Not a composition suited for a cover.
(Although I went with a profile view for volume 12)

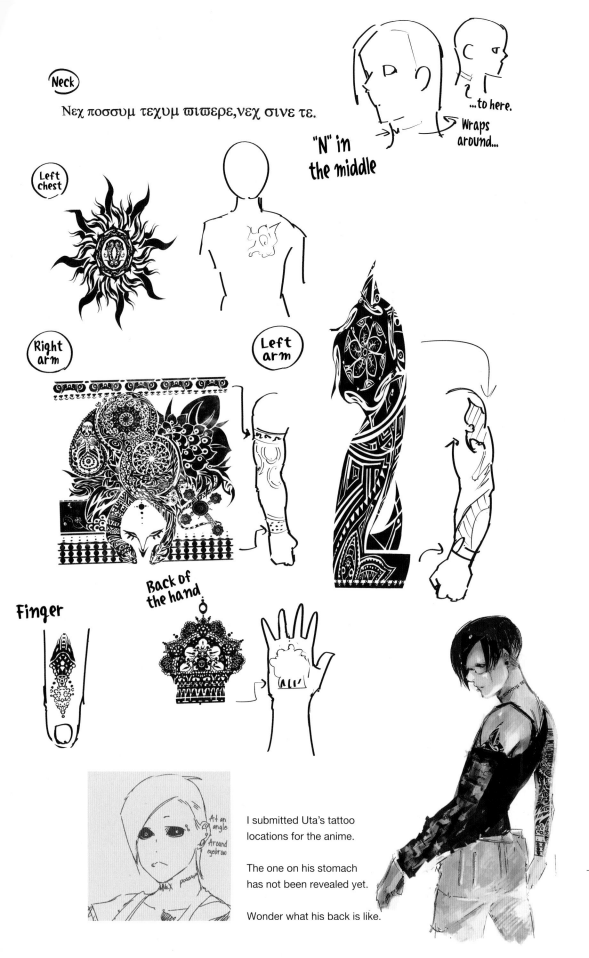

Neck

Νεχ ποσσυμ τεχυμ ϖιϖερε,νεχ σινε τε.

...to here.

Wraps
around...

"N" in
the middle

Left
chest

Right
arm

Left
arm

Finger

Back of
the hand

At an
angle

Around
eyebrow

NeX possum

I submitted Uta's tattoo
locations for the anime.

The one on his stomach
has not been revealed yet.

Wonder what his back is like.

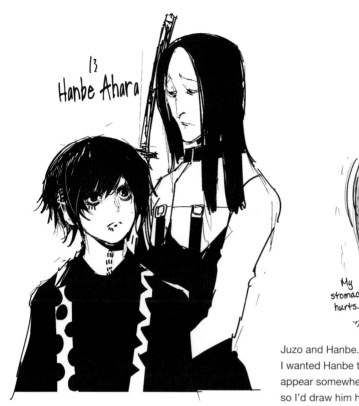

13
Hanbe Ahara

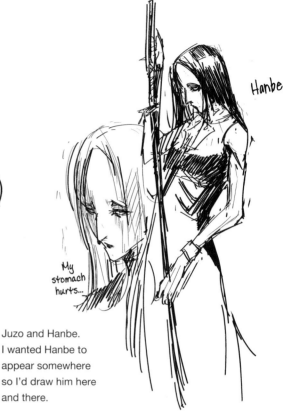

Hanbe

My stomach hurts...

Juzo and Hanbe.
I wanted Hanbe to
appear somewhere
so I'd draw him here
and there.

· Nishiki

Snakelike

Tie around neck

One-shot on WJ

· Hinami

Hetare mask
(by Uta)

Entire head

Like a costume

· Use the one in #113 for Yoshimura

· Uta

Tribal tattooish
Like the sun

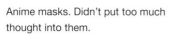

That's
bad
manners
...

PTT

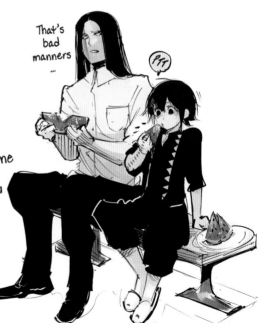

additional illustrations

Anime masks. Didn't put too much
thought into them.

Boss and underling

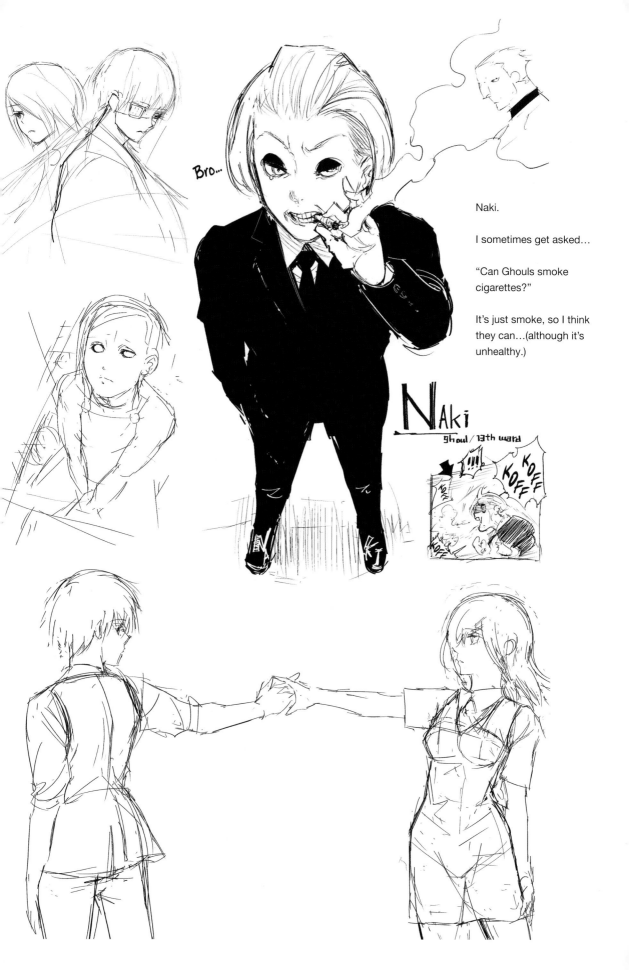

Bro...

Naki.

I sometimes get asked...

"Can Ghouls smoke cigarettes?"

It's just smoke, so I think they can...(although it's unhealthy.)

Naki
ghoul / 13th ward

KOFF
KOFF

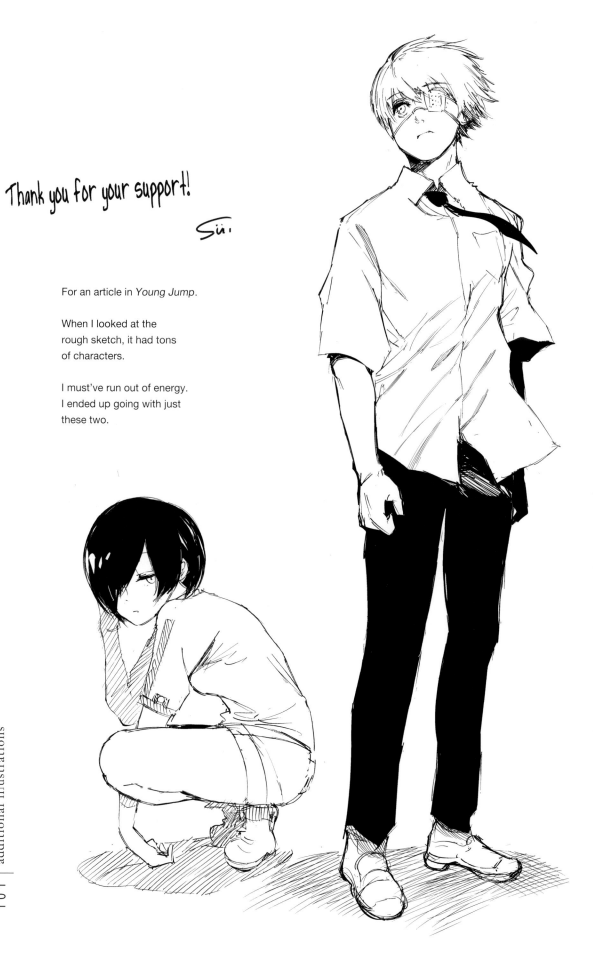

Thank you for your support!

Sui.

For an article in *Young Jump*.

When I looked at the
rough sketch, it had tons
of characters.

I must've run out of energy.
I ended up going with just
these two.

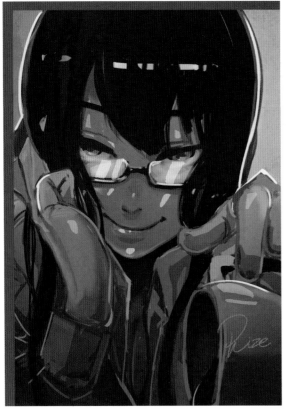

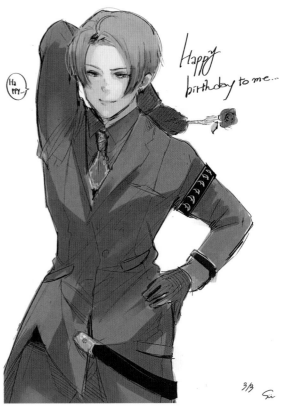

I kinda like Tsukiyama like this.
(Not that I hate him any other way…)

Volume 13
On sale today.
Pick up a copy.

Sui Ishida

Kaneki in glasses.

The cover for volume 13 was Arima (with glasses), so I put them on Kaneki too.

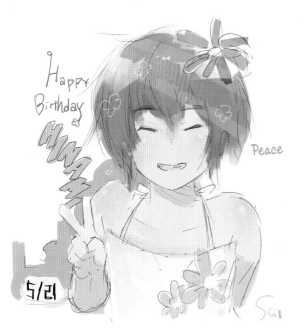

Happy Birthday MINAMI

Peace

5/21

Hinami's birthday. Hinami likes flowers.

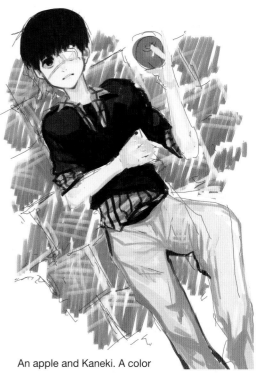

An apple and Kaneki. A color illustration from very early on. Rejected for something.

Akira and Maris Stella posing.

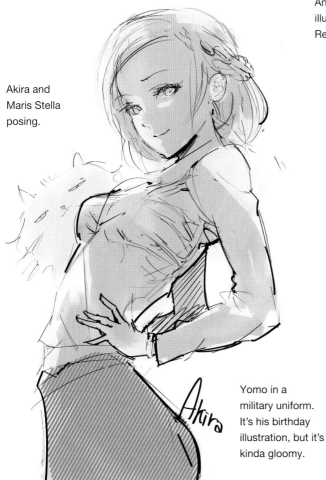

Akira

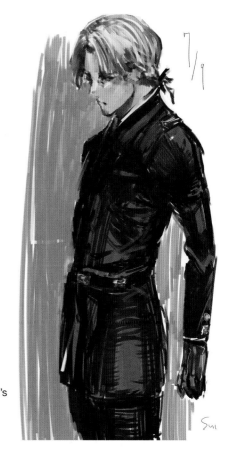

7/9

Yomo in a military uniform. It's his birthday illustration, but it's kinda gloomy.

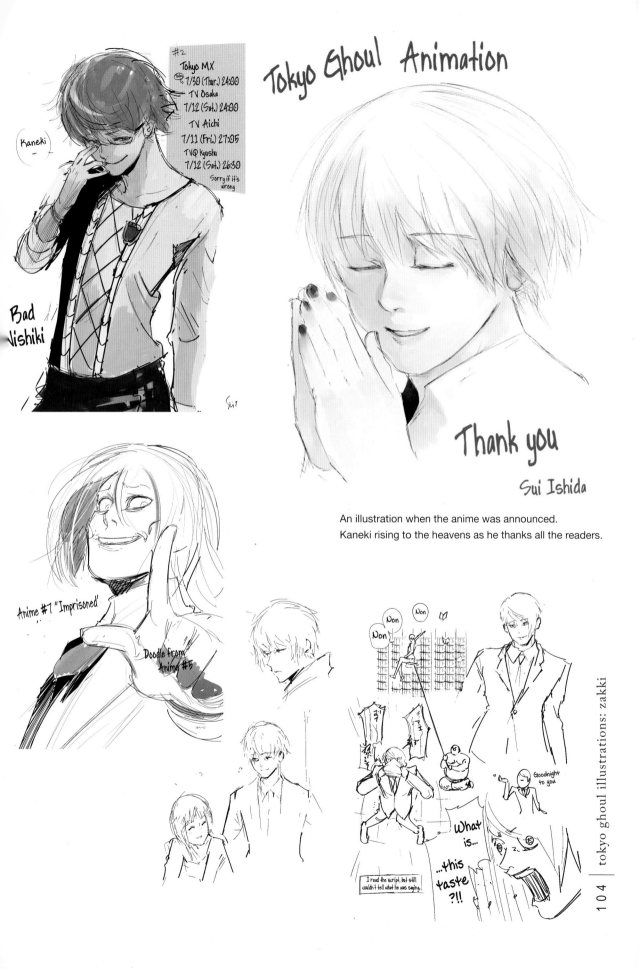

Tokyo Ghoul Animation

"Kaneki"...

#2
Tokyo MX
7/30 (Thur.) 24:00
TV Osaka
7/12 (Sat.) 24:00
TV Aichi
7/11 (Fri.) 27:05
TVQ Kyushu
7/12 (Sat.) 26:30
Sorry if it's wrong

Bad Nishiki

Thank you

Sui Ishida

An illustration when the anime was announced.
Kaneki rising to the heavens as he thanks all the readers.

Anime #7 "Imprisoned"

Doodle from Anime #5

Non
Non
Non

Goodnight to you

What is...

...this taste ?!!

I read the script, but still couldn't tell what he was saying.

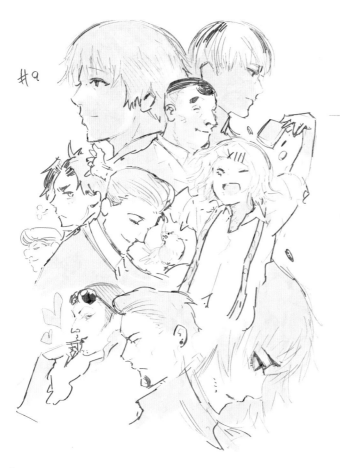

#9

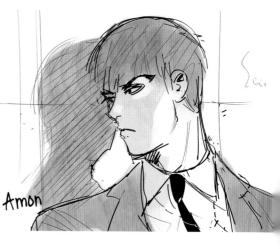

Amon

When I had the energy, I would doodle after watching the anime.

I watched episode 5 in real time as I doodled, but I gradually lost interest in drawing. I drew Nishiki pretty carefully.

All kinds of characters appeared in episode 9 so I drew a lot. I forgot to draw Koma so I added him later on.

Hoji's voice was really good…

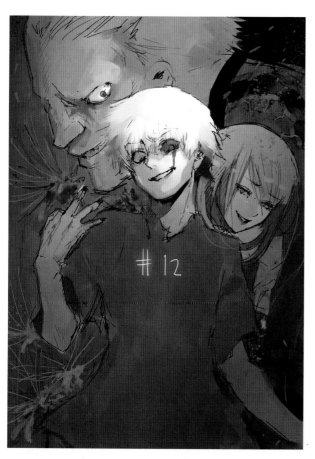

12

#8

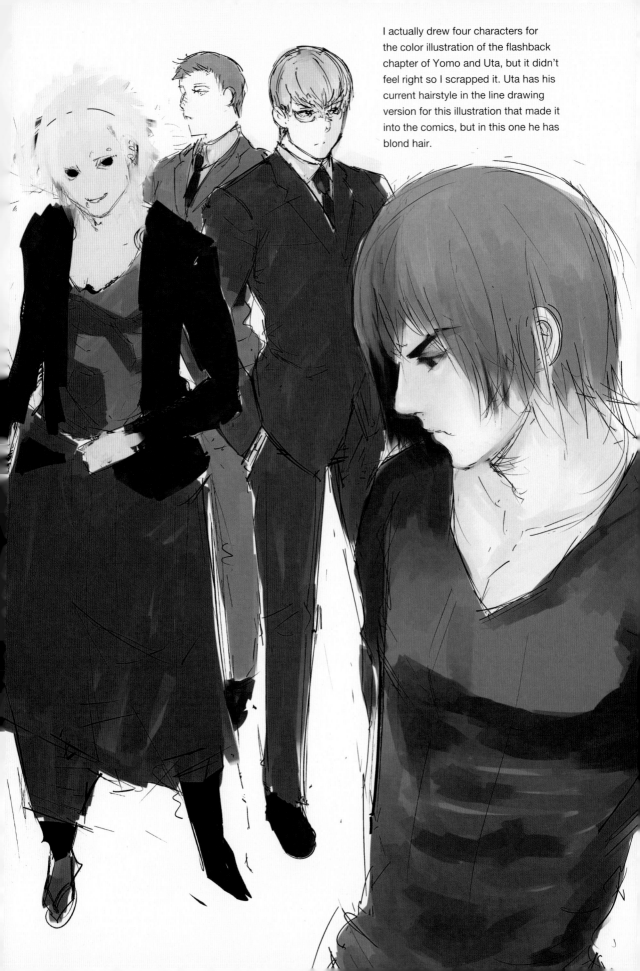

I actually drew four characters for the color illustration of the flashback chapter of Yomo and Uta, but it didn't feel right so I scrapped it. Uta has his current hairstyle in the line drawing version for this illustration that made it into the comics, but in this one he has blond hair.

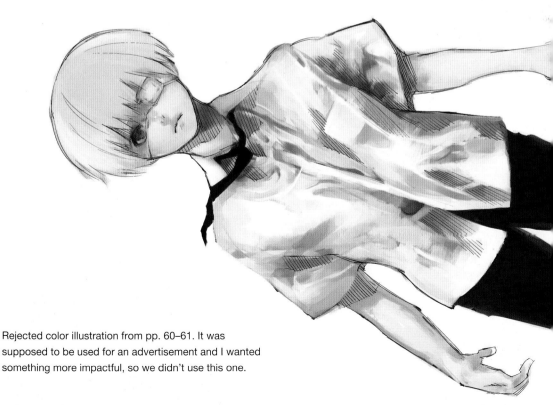

| additional illustrations

Rejected color illustration from pp. 60–61. It was supposed to be used for an advertisement and I wanted something more impactful, so we didn't use this one.

#143 *Young Jump* cover art.

I initially submitted a version with him blindfolded, but they asked me to show his eyes. (Of course…)

Like the cover for volume 14, I still don't know what I was feeling when I drew this.

III
Young Jump 2014 ● No. 42 ● Cover

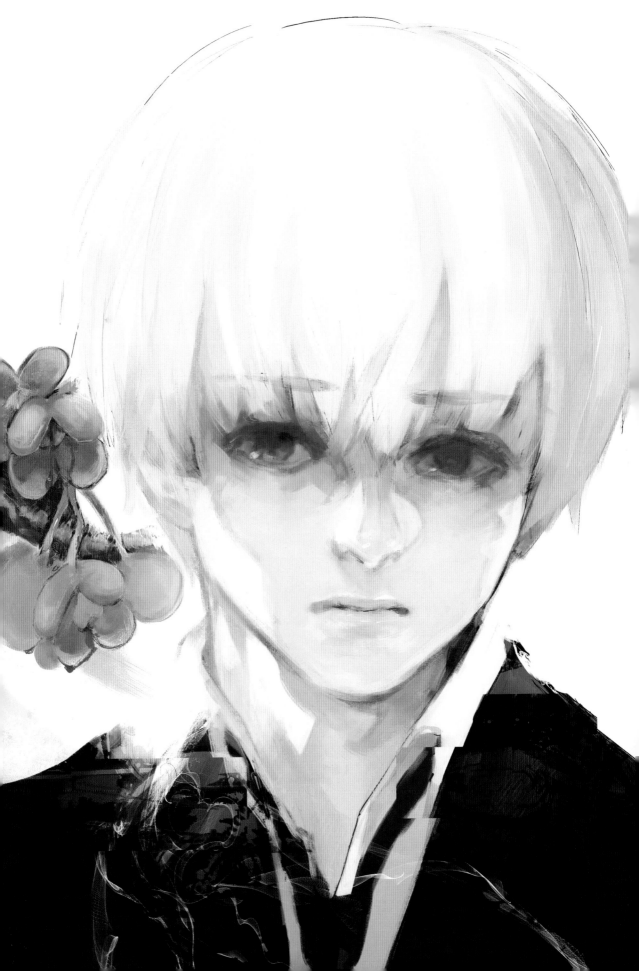

Even if I'm engrossed in what I'm drawing, once
it's done, I lose interest. So I don't usually look
back at my art.

Thinking about what I drew over the three years
Tokyo Ghoul was serialized...

Some pieces were good. Some weren't, but I tried
the best I could at the time. Some were just bad.
Some went through trial and error. Some I cut
corners on. The results were varied.

As I examine them, thinking of what I felt at the
time, my skills at the time, and mainly, my situation
schedule-wise...

I realize they were all intertwined. That's how each
and every one of them was drawn.

I hope you enjoy these illustrations, including the
struggles I went through with them.

2014.9.25 **Sui Ishida**

TOKYO GHOUL

TOKYO GHOUL
[ILLUSTRATIONS]
z a k k i
TOKYO GHOUL
東 京 喰 種

SUI ISHIDA

TRANSLATION **Joe Yamazaki**

TOUCH-UP ART AND LETTERING **Vanessa Satone**

DESIGN **Shawn Carrico**

EDITOR **Joel Enos**

JAPAN/ORIGINAL DESIGN **Local Support Department**

(Hideaki Shimada, Daiju Asami, Chika Suehisa, Daichi Usui)

JAPAN/PLANNING/ORGANIZATION **Kisousha**

(Chinami Nakamura, Yoshihiko Tozawa, Miho Suzuki)

JAPAN/PUBLISHER **Haruhiko Suzuki**

TOKYO GHOUL [ZAKKI] © 2014 by Sui Ishida
All rights reserved.
First published in Japan in 2014 by SHUEISHA Inc., Tokyo.
English translation rights arranged by SHUEISHA Inc.

Printed in China

Published by VIZ Media, LLC
P.O. Box 77010
San Francisco, CA 94107

10 9 8 7 6 5 4 3 2
First printing, November 2017
Second printing, May 2021

VIZ MEDIA *VIZ SIGNATURE*